THE ART OF
DEATH

THE ART OF DEATH

VISUAL CULTURE IN THE ENGLISH DEATH RITUAL
c. 1500 - *c.* 1800

NIGEL LLEWELLYN

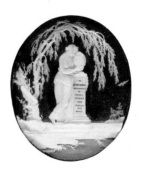

PUBLISHED IN ASSOCIATION WITH
THE VICTORIA AND ALBERT MUSEUM
BY REAKTION BOOKS · LONDON

For Clare

Published by Reaktion Books Ltd
in association with the Victoria and Albert Museum

Distributed throughout the world to the booktrade
by Reaktion Books Ltd
1–5 Midford Place, Tottenham Court Road
London W1P 9HH, UK

First published 1991, reprinted 1992
Copyright © 1991 the Board of the Trustees of the
Victoria and Albert Museum and Nigel Llewellyn

Designed by Humphrey Stone
Jacket design by Ron Costley

Photoset by Rowland Phototypesetting Ltd,
Bury St Edmunds, Suffolk
Printed and bound in Great Britain
by BAS Printers Ltd,
Over Wallop, Stockbridge, Hampshire

British Library Cataloguing in Publication Data

Llewellyn, Nigel
The art of death: visual culture in the English death
ritual c. 1500 – c. 1800
1. Visual arts. Special subjects. Death
I. Title
704.9493069

ISBN 0-948462-16-7

CONTENTS

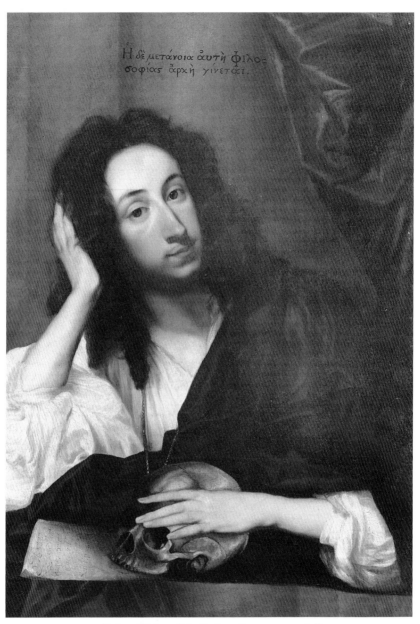

1. Robert Walker, *John Evelyn*, oil on canvas, 1648.

INTRODUCTION

How did our ancestors die? Biographers, demographers and historians of medicine can provide some answers to this question, but the full cultural complexity of death eludes conventional historical methods. Death is both a moment in time and a ritualized process; it also refers to a physical transformation and a social phenomenon. Such a complex picture demands flexibility in historical discourse; for example, all of what was meant by 'dying' cannot be disclosed by data on death rates plotted on a graph.

For one reason or another, everyone finds death difficult; as the seventeenth-century poet Henry Vaughan wrote: 'Yet by none art thou understood'.[1] Society expects historians, like scientists, to reveal the truth about contradictory phenomena; but death resists such an interpretation. The whole subject is simply too complex to be treated in one single history. Rather, there are many histories of death, of which this – an essay on the visual culture of the post-Reformation ritual – is but one.

In later sixteenth-century England, and beyond into the seventeenth and eighteenth centuries, a sophisticated ritual was developed in response to death, accompanied by a rich culture of visual artefacts. The role that such images and objects played has never been investigated; but their part, I would suggest, was central in establishing and sustaining all the processes of the English death ritual over this post-Reformation period. I hope that the complexities of this ritual do not make my arguments impossible to follow. The structure or narrative I have adopted does, however, need a few words of explanation.

The objects will be discussed in a sequence which will be unfamiliar to readers used to the traditional pattern of art-historical literature. The chapters are neither on chronological themes nor are they studies of topics such as medium, artist and patron, subject-matter or genre. What has determined the structure of the book is the course that was taken by the death ritual, which, I argue, was directly responsible for producing this particular set of cultural artefacts. The story commences with the role of prints and pictures in preparing the spirit prior to the moment of physical death; another topic taken in the opening section describes how representations of the moment of death were expected to teach the living how to die. This is followed by a discussion of the visual culture associated with the decaying natural body and further sections on the funeral rites,

mourning, commemorative art and, finally, illustrations of the poetic and historical *topoi* of the contemplation of the ancient tomb. Despite the span of time suggested by the subtitle, I have not set out to survey the whole period with equal attention. The Reformation had some immediate effects on the visual culture of the English death ritual; other aspects of the problem took many generations to resolve. This inconsistency is reflected in the examples given and the objects discussed and illustrated, which tend to favour the sixteenth and seventeenth centuries. However, I would not want to suggest that many of the most important themes in the book could not have been illustrated by eighteenth-century objects and, as is well known, there was a spectacular visual culture of death in the nineteenth century.

In planning this book I have had to decide how to juxtapose the theories about death held by anthropologists, sociologists, psychologists and others with discussions about objects. This is a standard dilemma for the art historian and I have decided not to section off theory in an opening *apologia* but rather to feed regularly into the text questions such as how visual artefacts emphasised continuity; what kind of visual representations were suddenly required in the face of death; why was the human 'person' – conceived both as a body and a personality – not homogeneous but imagined in diverse ways; and why were there tensions and conflicts between the private and public aspects of death, grief and mourning.

Throughout, I have juxtaposed discussions of this kind with the objects to which they relate. It is, of course, not a perfect solution. Some might argue that it is important to know about the theory of the Two Bodies before considering a single picture or image. Such a strategy would, however, have set up the kind of theoretical ghetto which might all too easily be isolated from the artefacts themselves. So, I have decided to follow the overall narrative shape of the exhibition itself and introduce theoretical material rather more organically. Should the reader reach the final page, all the main themes will have been made available.

Some of the sub-headings refer to groups of objects and are self-explanatory; others introduce sections which treat more abstract ideas and may appear obscure and even irrelevant. In the process of labelling, years of study of epitaphs and printed ephemera associated with death have left their mark: I seem quite unable to resist terrible puns.

I · THE OBJECT
OF COMMEMORATION

A few embroidered words worked on a sampler dated 1736 illustrate the cultural complexity of the ritual that followed a death in post-Reformation England:

> When I am dead, and laid in grave,
> And all my bones are rotten,
> By this may I remembered be
> When I should be forgotten.[1]

In one sense this simple artefact is clearly intended to be commemorative. The author is imagining the world after her death. Yet the consistent use of the first person and the confused array of tenses reveals a more complex sense of time and purpose in these verses. The 'I' suggests that the embroiderer was party to the writing of the text and, we assume, to the making of the sampler itself. Today, commemorative art is made for other people; it is rarely by artists about themselves. So what precisely is it that the sampler will commemorate? We might imagine the person in a gruesome future state, as a physical body in a state of transition – the rotten bones referred to by the author. But there are other aspects of the person besides. Though their author exists in the present and has a living, functioning body, the words address a future reader who, in that time to come, will be contemplating the past. Several bodies can be inferred in this short rhyme. Nearest to us is the living body holding the needle and responsible for the embroidery. Further away, in the future, there is the dead body, divided in turn into two aspects. The first, the social body after death, is sustained in our memories by artefacts such as this very sampler; the second, the natural body after death, is lifeless, alien and used up. One of the most problematic aspects of the visual culture made to accompany the English death ritual is its habit of obscuring precisely which of these several bodies is its concern.

Samplers were so named because they were expected to act as *exemplars* of both skill and sentiment. Painted and printed pictures were also used as examples of moral virtue and employed the complex image of death which was so characteristic of the ritual. This is the little-studied group of images, mostly of modest size for domestic settings, of subjects in the

[9]

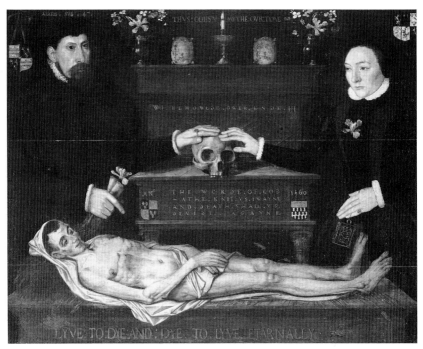

2. *The Judd Marriage*, oil on panel, 1560.

memento mori tradition. These pictures show how visual culture prepared people for death during their own life-times. Such a function suggests, at the very outset, that these representations originally formed part of a *genre* or discourse quite distinct from the present-day concept of 'high' or gallery art. They make no allowance for an eye trained in the tradition of conscious self-referencing that is so important in Italianate picture-making of the kind usually given priority in histories of English art.[2] In the small panel painting known as the *Judd Marriage* (illus. 2), the function is, perhaps, unclear.[3] The unfamiliar juxtaposition of portraits and a corpse is rather unsettling. In our culture the states of life and death are twinned, yet invariably opposed. The two words tend to be used with connotations of a strong contrast, as between the positive and negative of an electrical current, between black and white or good and evil. Post-Reformation emblematic images such as the *Judd Marriage* are, however, intended to present life and death as part of a single cultural process, not as opposing values in a crude binary model of the human condition.

In the *Judd Marriage* panel the upper section accommodates a single social body: a couple united by marriage. Below them, laid out as if on a

slab, and following the pattern of some earlier funeral monuments, the natural body is represented in allegory or personification by a corpse. This figure looks male but its face does not show the features of the male Judd portrayed immediately above. The couple make their vows on a skull, a symbol of transience and mortality. Below is a text concerning the sacrament of marriage, already celebrated:

> The word of God
> Hathe knit us twain
> And Death shall us
> Divide again.

Their coats-of-arms and the date '1560' might well supply a future historian with enough information precisely to identify them.

The couple are shown half-length, in fashionable dress surrounded by a mass of verbal and heraldic signs, occupying an ambiguous physical space. We should not expect to look into this scene as through a window on the real world for it is an account of a particular spiritual condition. It restates the age-old marriage vow 'Till death us do part'. The vow itself is taken on the skull, the most powerful contemporary symbol of the consciousness of death, and the Judds's virtuous speculation on their own passing is recorded in the image of the corpse which articulates the words 'We behold our end', a motto in a style found on countless artefacts of the *memento mori* type, including the sampler.

In addition to delivering its moralizing message, the picture was clearly intended to act as a memorial. The inscription on the frame claims that it will keep the memory of the Judds alive after their deaths: 'When we are dead . . . by this shall we remembered be . . .'. These verses are close in sentiment to those found on less obviously moralizing contemporary portraits, for example that by Hans Eworth of a woman aged thirty-six which ends with the words 'Y ons was young and now am as you see'.[4] There are many versions of this text. They all rely on the evergreen observation that birth is simply the first step on a journey through life to reach death, or, as appears on a mid-seventeenth-century medal:

> As. Soone. As. Wee. To. Bee. Begvnne:
> We. Did. Beginne. To. Bee. Vndone.[5]

In many of these texts, especially those shown on funeral monuments in public spaces, the corpse issues even more direct instructions to the beholder: 'Behold, I was as you are, and you will be as I am'. Sometimes an apparently invulnerable image and a text redolent of frailty are poignantly juxtaposed, for example in the Latin version found alongside the remnants

of the monument to Richard Sale (*d.* 1615) set up in a church in south-east Derbyshire:[6] 'Ecce nosce te ipsum. Ut sum tu eris'. The *Judd Marriage*, in contrast, was almost certainly intended for a private, domestic setting.

This picture is primarily about the centrality of rites of passage in human existence. It is also about the relations between those rites and the patterns which underlie our experience of life. The structural relationship between two of these, death and love, or the end of one life and the process which leads to the start of another, is particularly important. Love and Death, or Eros and Thanatos, was the subject of special fascination in the Renaissance and during the nineteenth century when it was taken up by poets such as Tennyson and the librettists of such operas as *Tristan und Isolde*. In Germany in the early sixteenth century, the Beham family produced an extraordinary series of erotic engravings on the subject of death. Early in the nineteenth century Thomas Rowlandson produced a vivid series of drawings on this theme: in *Dead Alive* a suspicious husband feigns death and rises from the coffin to catch his wife in the arms of her lover; in another scene Death helps an 'Old Lover' into bed, where he will attempt to satisfy a pretty young mistress.[7] In terms of ritual alone, manifold parallels have been noticed between the cultural practices of birth and death, such as the role of the bed, the washing of the body and the giving of flowers. Today, weddings have been transformed into events constructed as the opposite of the funeral: white against black; life against death; youth against age; joy against sorrow, and so on. But so close were the structural relations between such rites of passage in early modern English culture that weddings might trigger the contemplation of mortality. Take, for example, the behaviour of the diarist John Evelyn (1620–1706), who, in 1647, married Mary Browne in Paris and wrote for her a short treatise on wedlock. During the following year his thoughts turned to his own mortality and he had himself portrayed by Robert Walker (illus. 1). Evelyn personifies the classical poet musing on melancholy, with a skull, a copy of Seneca's *De brevitatae vitae* and, on the wall behind him, a quotation on self-knowledge from this work: 'Repentance is the beginning of Wisdom'.[8]

II · RITES OF PASSAGE

The death ritual and its attendant objects occupy a place in human existence that anthropologists describe as liminal, a transitory moment set between the polarities of life and death.[1] This liminality is echoed by the stern warnings of the *memento mori*, often found on memorials, as well as on images concerned to forewarn. They were especially popular in England around 1600, although the existence of both Latin and vernacular versions is a reminder to us of the type's medieval origins. In a woodcut printed with John More's *A Lively Anatomie of Death* of 1596, the words are uttered by a shrouded corpse. The text reminds the reader that just as Joseph of Arimathea made his tomb in his own lifetime, so should the Christian man prepare for death with spiritual exercises and by setting up a monument. The importance of such preparations was also emphasized by the greatest apologist for Anglicanism, Richard Hooker, who would doubtless have approved of 'the Picture call'de the Sceleton wch hanges in the Hall', which John Donne bequeathed in his will.[2]

Certain more substantial works, such as the famous *Unton Memorial* picture of 1596 (illus. 28), reveal the death ritual as an extended process, a rite of passage rather than a single moment or event.[3] The *Unton* picture is not a portrait in the modern sense but it is a complex representation of Sir Henry Unton's life, his dying and his death. And, it illustrates how cultures construct meanings for death from combinations of religious teaching and personal experience. Unton's biography and posthumous history reveal that his death ritual was extended over a very long time as a cushion against his unforeseen demise. Having been knighted for military and diplomatic service Unton died in his early forties in the course of an important ambassadorial mission to France. He took to his sick-bed at Coucy La Fère with a serious illness which soon had him issuing orders about his own burial. His death on 23 March 1596 was followed by the removal of his body to England and its burial on 8 July at Faringdon, Berkshire, where there were already three generations of Untons commemorated in the north transept. His chaplain published a book of commemorative poems later that year,[4] and in August his widow, Lady Dorothy, was discovered in deep mourning at her father's house:

She has very well beautified her sorrow with all the ornaments of an honourable widow. Her black velvet bed, her cypress [mourning] veil, her voice tuned with a mournful accent, and her cupboard (instead of perfume sprinklers) adorned with prayer books, and epitaphs makes her chamber look like the house of sorrow.[5]

Lady Dorothy, who in 1598 married again and lived until 1634, was almost certainly the patron of the *Unton* picture. She was perhaps also the patron of an audible memorial composed by John Dowland, the leading lutenist of the day. In 1604 Dowland published a set of pieces, *Lacrimae, or Seaven Teares*, which included a sombre pavan entitled 'Sir Henry Umpton's [*sic*] Funeral'.[6] It was always assumed that this piece must have been written for performance at Unton's interment, but this interpretation ignored the sense of the word 'funeral', which had various indefinite applications with regard to death. It is now clear that Dowland was abroad in the summer of 1596; the music was simply another form of memorial. His pavan, in the subdued key of G minor, has a disquieting asymmetrical form and its harmonies employ momentary but striking dissonance in the inner voices. As we shall see, such discords were intended to intensify the emotional impact of music of this kind.

The *Unton* picture's form is also asymmetrical and even dissonant. Its design takes little notice of the conventions of Italian Renaissance picture-making. It is no window on the world, and within the picture space is irrational and inconsistent. But within the terms of the English death ritual the image is potent. The figure of Unton occupies a pivotal but not central position: he begins to write on an empty page, encouraged by miniature figures of Fame and Death, who, muse-like, are akin to the symbols sitting on the shoulders of Evangelists in some medieval illuminated Gospel books. Unton's pose – half-length with pen in hand – would have been familiar to his contemporaries, for it was increasingly popular in funeral monuments for clerics and academics around 1600. His representation establishes the kinds of scholarly connotations which were presumably thought fitting for the portrayal of a gentleman in the act of writing his own history. Death, armed with an hour-glass – a standard attribute, as time cannot resist the inevitable advance of mortality – utters the familiar motto '*Me[ment]e Mori*'. The picture field around this central motif is crammed with incident and not subject to any consistent perspectival system. It is both an emblematic image and, to some extent, episodic. Roy Strong has discussed the subject-matter of these scenes in terms of oppositions between private and public events from Unton's life; more accurately the whole picture is a public representation of an Elizabethan gentleman. All the important facets of a public *persona* are illustrated: the

noble descendant, the scholar, the soldier, courtier and diplomat, the host and the philanthropist.

On the right of the picture several incidents from Unton's life are arranged in narrative form as a journey which ends with his corpse crossing the sea, more like the Styx than the English Channel. Death approaches from the right side where the sun also governs. On the left, under the crescent moon, is the church where Unton's funeral service took place and the *cortège* moving forward from the left and invading the rhythm of a successful life expressed on the right. Unton's last journey, organized according to the degree of Baron (his ambassadorial rank), is witnessed by the poor, the innocent and the crippled – all beneficiaries of Unton's charity – and, with their backs to us, by crowds of onlookers. They are clear evidence of the strong didactic function of the public funeral rite, for Sir Henry is being buried as an example of honour and virtue.

In the extreme left corner is a picture of a monument, perhaps a representation of that finally completed at Faringdon in 1606, now lost except for a tablet and a kneeling figure of Lady Dorothy. The monument shown in the painting establishes a permanent memorial for Unton by means of inscription panels and sculpted personifications of his civic and moral virtues. It also deploys heraldic devices to establish his rank as a descendant from Edward Seymour, Duke of Somerset. The monumental, contemplative effigy of Sir Henry contrasts markedly with another representation lying alongside the monument. This is surely Unton's 'natural' body, with captions expressing his anguish prior to his death: '*O living gods . . . To die poore Wretch . . . am I*'.

The *Unton* picture, both as representation and as artefact, shows the characteristic extension of the death ritual even when death itself was unexpected: Unton dies in March 1596; is buried four months later; later there follows the publication of the volume of commemorative poems; and after about ten years Dowland's music and the completion of the monument.

Such a cultural practice has an emphasis which differs from the custom in contemporary society. More primitive systems of transport combined with the need to bring the body home would explain the delay over the funeral, but the overall extension of the death ritual does suggest that a characteristically different set of beliefs was at work in early modern England. In general, cultures impose boundaries on the natural process of dying and develop extended rituals in order to cushion the blow that death represents for the social fabric. In post-Reformation England the boundaries were set on the process of death at different points to those

most of us would recognize. Life was a phase of experience stretching back in time to birth; death was a future point when the termination of life could be objectively determined. The space between the two was the period of 'dying', potentially a time of social and personal instability, which encouraged a complex ritual in which visual artefacts were deployed to sustain the culture and help resist the havoc which death might wreak.

To some extent, contemporary capitalist cultures in the West still recognize that dying exists as a liminal point between life and death: we mostly agree on the good sense of preparing a will, a process which demands that we imagine the social world in our absence and which in a way foretells our own deaths. Most of us change our behaviour when someone close to us dies. Nevertheless, in the Western world death takes place at a distance, it is a pollutant which threatens hygiene; it indicates a time requiring strength, not emotions: death ignored might almost be death denied. In early modern England such denial was unfamiliar if not impossible and the clerics preached the wickedness of those who disregarded their own mortality. In response, the space between life and death, the ritualized period of dying, was stretched in ways which by today's standards would be considered tasteless and unacceptable.

III · DYING, A PROCESS

Case studies of commissions for funeral monuments, nearly all of which display their subject's date of death, show clearly this extended ritual. Some time around 1661 the Reverend William Evans erected a monument (illus. 3) in the north transept of Hereford Cathedral.[1] It commemorates the loss of his beloved wife, Mary, who died 31 March 1660 aged 37. The monument was richly carved and employed a composition becoming more fashionable in the 1660s: two arches, decorated with text, carved ornament and other visual signs, set round a portrait bust. Both image and text present Mary Evans as a model of virtue and one caption adapts the standard *memento mori*:

> All Women shall be, what she now is here;
> But what she was, few Women are, few were.

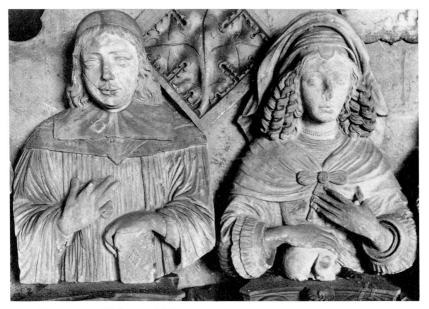

3. Monument to William and Mary Evans, freestone, *c.* 1660. Hereford Cathedral.

To the modern eye there is one remarkable feature of this tomb: the patron has included himself alongside his late wife. This action seems even more outlandish when we imagine the audience for this kind of commemorative art. The monument was put up in the Cathedral to which Evans donated books and where he held a prebend. In post-Reformation England attendance at church was a way of publicly reaffirming one's loyalty to the state as well as participating in an act of devotion. This was especially so in the case of Evans, who was a Royalist and had been a prisoner of the Parliamentarian forces that had taken the city in 1643. At every service Evans attended, his living presence would have been complemented by his representation in stone. As he got older the disjunction between the two images would have slowly become more and more marked until, with his death in 1668, only one public image would have survived, a triumph of art over life. Such an association of images is, in our experience, beyond the bounds of possibility. Some of us may learn to live with our own portrait but we are not asked to pose for one as if dead. Yet in post-Reformation England it would appear that this practice was commonplace; approximately one third of the funeral monuments erected were intended to commemorate, and thus represent, the living.[2] What Evans and so many of his contemporaries undertook was an imaginat-

ive leap into the future; writers sometimes did the same. In 1714 Matthew Prior wrote verses 'For his own Epitaph', a subject which today would be regarded as obsessive or only darkly humorous.[3] In *Castle Rackrent* (1800) the novelist Maria Edgeworth spins a comic yarn about an attempt, which backfires, to extend the ritual. Old Sir Condy Rackrent, lying ill, has 'a great fancy to see [his] own funeral afore [he] dies' and directs his servants to simulate his demise. As the house fills with funeral guests he is disappointed not to hear much comment on his many good qualities, abandons the deception and joins the party.[4]

The time of dying included an important preparatory phase. The process of dying was a rite of passage – a time for repairing any damage which death might cause to the social fabric and for establishing a suitable commemoration to replace the deceased. To understand the post-Reformation English death ritual we must reject our binary model, which presents death in simple opposition to life, and imagine another phase called 'dying'. This liminal point was sometimes reached well before the moment of natural death itself and, as in the text of the sampler, the early stages of dying might be actively participated in by the subject, who was encouraged to make preparations of various kinds. With the aid of considerable literature, such as the English edition of *De preparatione ad mortem* by Erasmus, they prepared their spirits for the afterlife, newly described by the Reformers. And they prepared their worldly selves as demanded in law. A modest printed literature was produced to help testators write useful wills: William West's *Symbolaeographia* (1590) contains specimen wordings, and more advice was available in Thomas Wentworth's *The Office and Dutie of Executors* (1641).[5] It was to the state's advantage that the transfer of property following a death was assisted by the making of a will, and when the reading of the last testament was in itself a matter of supreme importance in the body politic, the document which bore the text was carefully designed and executed for display and decoration. The copy of the will of Henry VII is a splendid example of the genre.[6] The living and continuous authority of the political body of the King is represented by a portrait miniature of the enthroned monarch. The text itself is beautifully lettered, and bound in a splendid clasped cover encrusted with jewels. Kingdoms could be won and lost on the strength of such documents.

IV · DANCES OF DEATH

The English Church, both before and after the Reformation, placed great stress on spiritual preparation. This was to be undertaken as much by the living as by the dying: all were to hold themselves in daily expectation of their own demise.[1] These devotional exercises were assisted by an extraordinary range of visual artefacts of the *memento mori* type, together with moralizing texts such as *The Dance of Death* and descendants of medieval poems such as 'Erthe upon Erthe . . .'.[2] All this prepared the sinner for the afterlife and helped the bereaved make more sense of the loss of an individual by turning the experience of death into a didactic *tableau*. The Reformist laws seem to have given an impetus to images of the *memento mori* type just when the state was being actively discouraging about icons in their traditional Roman role as means to intercession.[3]

Images reminding people about their own mortality were to be found in all kinds of public and private situations: as furnishings, on the walls of buildings and carried about the person. Rings and other mourning tokens eased the sudden pain of an individual death by suggesting that the bereavement was part of some great design and by stressing the positive aspects of death as a learning process. Reminders of mortality were included on countless woodcuts, embroidered samplers, in drawings, paintings and printed books and on medals and even trade tokens.

In the popular consciousness the most powerful force among all this moralizing imagery was the so-called Dance of Death, which was taken as a subject by many poets and artists associated with England, from Hans Holbein (illus. 4, 5) through to Rowlandson, whose *English Dance of Death* (1815–16) has as its frontispiece *Death Seated on the Globe* (illus. 7).[4] Rowlandson's great series of drawings for prints were produced at the rate of one per month and presented to the poet William Combe, who supplied the texts.[5] The sixteenth-century Dance of Death was closely related to such early publications as *The Art of Good Lywyng and Good Deyng* (illus. 6) and to the plot and drama of the confrontation known as the *Three Living and the Three Dead*.[6] In the latter, during the course of a journey a small group of mortals are suddenly accosted by a party of the dead, with horrifying results. In all such works the main focus of didactic attention, that is the means by which the artists tried to persuade their viewers to abandon sin and live a life of virtue, is on the contrast between the living

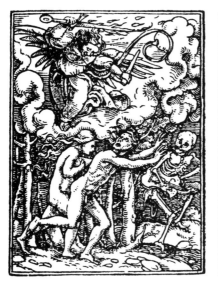 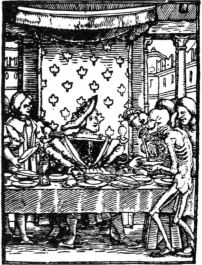

4, 5. Hans Holbein the younger, 'The Expulsion' and 'The King', woodcuts from
The Dance of Death, 1538.

6. Illustration from *The Art of Good Lyvyng and Good Deying*,
woodcut, *c.* 1520.

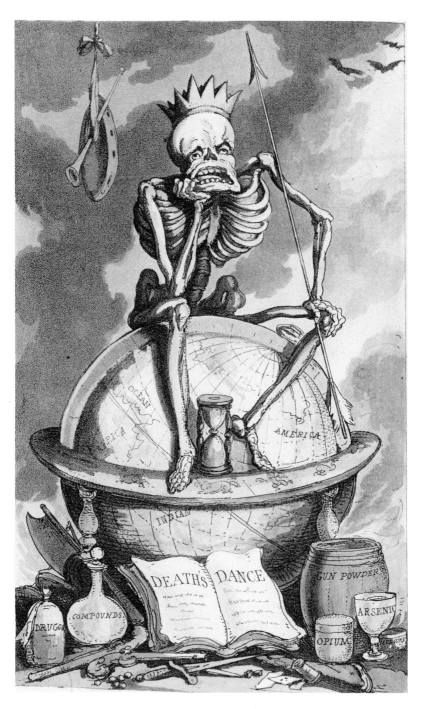

7. Thomas Rowlandson, 'Death Seated on the Globe', frontispiece
to *The English Dance of Death*, colour aquatint, 1816.

and the dead. The living were often shown as well-to-do and fashionably dressed, and the dead as subversive, trans-sexual and no respectors of the niceties of social discourse. The more dramatic and unexpected their confrontation and the more stark the opposition between the social status and physical state of the two sides, the stronger the didactic appeal.

In the hands of some later artists, the appeal could also be humourous. Richard Dagley's *Death's Doings* (1827), with its 'numerous original compositions in prose and verse', juxtaposes the shock of death's sudden blow with the control and composure of the sportsperson: one scene shows Death as a victorious boxer called 'The Champion' and another has Death as a demon bowler in a cricket game in which Chance keeps wicket (illus. 8). As early as the 1750s William Hogarth had used a similar idea in two preliminary drawings undertaken for a monument to George Taylor, a famous pugilist. Their titles suggest a rather more equal balance between the two adversaries in the endless fight for supremacy: *Death Giving George Taylor a Cross-buttock* (illus. 9) and *George Taylor Breaking the Ribs of Death*.

The purpose of the *Dance of Death* is clarified by the title-page of a late eighteenth-century edition of Holbein's set of designs 'wherein is lively expressed and shewed the state of manne'. This is not simply a metaphor for the human enterprise, but a literal claim. The series of forty-one woodcuts by Lützelburger, after Holbein's drawings, was finished by 1526

8. Richard Dagley, 'The Cricketer', from *Death's Doings*, etching, 1827.

9. William Hogarth, 'Death giving George Taylor a Cross-buttock',
red chalk and charcoal, ?1758–9.

but not published until 1538, in Lyon.[7] Holbein's court portraits, most
famously of Henry VIII and Sir Thomas More, supply us with what sense
we have of the physical character of the chief actors in the political and
social drama of the English Reformation; in Continental Europe, however,
Holbein's reputation was established mainly by his graphic works, foremost
among them the *Dance of Death*. A point of connection between these two
genres is his half-length portrait of *Sir Brian Tuke* with an hour-glass and
Death armed with a scythe looming behind (illus. 10).[8] Holbein's designs
for the *Dance of Death* were famous throughout Europe by the time he
died in 1543. The set of woodcuts was pirated and copied on dozens of
occasions over the next sixty years or so.[9]

The printed versions of the *Dance of Death* follow the original format,
which is a serial representation in which the living and dead mingle in an
energetic procession painted on a wall, perhaps of a churchyard or some
other burial place. The *Dance of Death* was characteristic of the early
modern death ritual in two ways: first, the living appeared in the order of

10. Hans Holbein the younger, *Sir Brian Tuke*, oil on canvas.

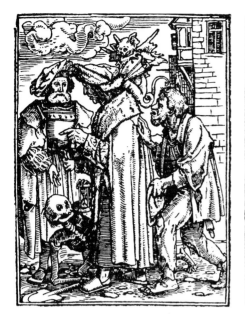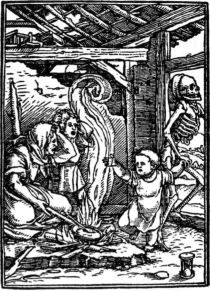

11, 12. Hans Holbein the younger, 'The Councillor' and 'The Young Child',
woodcuts from *The Dance of Death*, 1538.

their social rank, that is, emperors and kings followed by nobles, the gentry,
the people and so on; second, the dead were displayed as part of an
instruction to the living about the nature of death. Viewers took the dance
of the living and the dead to refer to their own mortality. Sixteenth-century
versions of the theme, Holbein's especially, stressed its didactic application
in the tradition of the *memento mori*: Death was ready to strike anywhere
at a moment's notice. Thomas More's reflections on the cycle at Old St
Paul's indicates this development, producing a sense that 'death' is already
in all of us:

We are never so greatly moved by the beholding of the Dance of Death pictured
in Paul's, as we shall feel ourselves stirred and altered by the feeling of that
imagination in our heart. And no marvel. For those pictures express only the
loathly figure of our dead, bony bodies, bitten away the flesh; which though it be
ugly to behold, yet neither the hight thereof, nor the sight of all the dead heads
. . . is half so grisly as the deep conceived fantasy of death in his nature, by the
lively imagination graven in thine owne heart.[10]

Holbein's *Dance of Death* (illus. 4, 5, 11, 12) stresses social rank; the artist
was concerned with physical characteristics. As the king sits at the table –
with his feet set as they are in Holbein's famous image of Henry VIII –

Death pours his wine. The very symbols of power are points of vulnerability. The power of the Pope to anoint princes is subverted; that of the Emperor to rule princes is challenged, as Death removes the crown; the Cardinal, about to sell an indulgence, also has his hat removed; the Empress in her finery is confronted by a grave as she walks through the city. And always there is the hour-glass, Death's emblem. The series also focuses on the universality of death: 'Who is the man, however strong or great/Who can escape the final destiny?' This kind of sentiment was a striking instance of what was alarming about death, and thus the focus of the ritual was on the way devotional or spiritual preparation tended to deny differentiation.

The cycle starts with a Creation scene with Death cast as the sinful aspect of humankind; he is the mark of sin, its reward and punishment. Death appears in every scene except the Creation, the Temptation and at the Last Judgement, in fact, wherever mortals are the main characters. He takes the form of a skeleton – a transitional and corrupted form of the natural body which, after the Fall of humankind described in the second scene taken from Genesis 3, always accompanies the social body and is, indeed, its other facet.[11]

Death 'himself' is the main actor in the countless variants of the *memento mori* imagery which survive: he scythes through the ranks of the proud, creeps up on the unwary with his bow and plague arrow, and frightens all and sundry. His lack of respect for social degree and his indiscriminate behaviour were especially terrifying. He grins, allows near escapes, but always conquers. His expressionless features deny the powerful inherent semiotic quality of the human face, and signify a separate kind of existence, 'the other' to the living human. This skull appears on even modest domestic paraphernalia, including spoons (illus. 13) and snuff-boxes (illus. 14), as well as in didactic arts, such as in woodcuts, illustrations in books or, like the *Judd Marriage*, as separate pictures designed to hang on the wall. In early modern England Death always accompanied the individual on the streets or at home among the family.

In preaching the socially undifferentiated universality of death, the *Dance* revealed its Protestant character. The Reformation in fact produced a crucial adjustment in the attitude of the living towards the dead. Under the old theoretical orthodoxy Christians lived in constant expectation of the Second Advent, the *Dies illa* trumpeted at the Requiem Mass, that day upon which 'Time and History' would end.[12] The delay in the Second Coming had encouraged speculation about the fate of the Christian soul at death, and the result was the doctrine of Purgatory rejected by the Reformers along with the trappings of Papal authority. The traditional

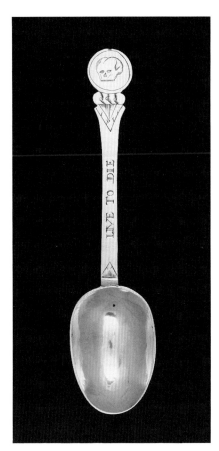
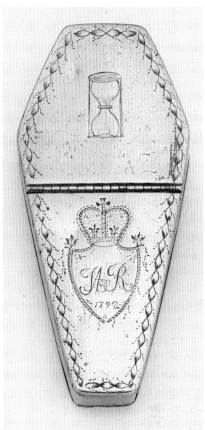

13. Thomas Mangy, Mourning Spoon for a member of the Strickland family, silver, 1670–71. 14. English Snuff-Box, copper, inscribed 'JAR 1792'.

belief about Purgatory had created a popular image of the afterlife as a place where the souls of the dead might be imagined residing after the decease of their natural bodies, but before the Last Judgement. Purgatory also allowed the living a sense of contact with the dead through prayer, perhaps chanted by priests specially retained for the purpose, in chantry chapels. One of the Reformers' main grievances was against the whole corrupt practice of indulgences, an industry built on the idea of Purgatory. Inscriptions on countless monuments which beseached passers-by to pray for the dead – 'orate pro nobis . . .' – encouraged this sense of contact, but such wordings were expressly forbidden by reformist statute. The ending of Purgatory thus caused grievous psychological damage: from that point forward the living were, in effect, distanced from the dead.

[27]

V · EXAMPLES OF VIRTUE

To balance the traumatic effect of the loss of Purgatory the Protestant churches gradually developed the theory of *memoria*, which stressed the didactic potential of the lives and deaths of the virtuous.[1] To illustrate this didactic theme images were produced about exemplary 'good' deaths: the innocence or good scholarship of a dead child, the pathos of a dead soldier, the heroism of a death met in a great cause, the sacrifice of a martyr, the tranquillity of an old man dying, the virtue of a good wife dying. In some cases the moment of death itself was thought worth showing. Sudden deaths were regarded quite differently. The absence of preparation could result in spiritual and social condemnation and such 'bad' deaths were to be avoided at all costs. Where they did occur, images were produced to warn others against a similar fate.

The reconstruction of the emotional bonds within a family in the historical past is notoriously difficult, and more difficult still is its translation into modern terms. One account has it that early modern people were so embattled by the world and so familiar with death as an everyday occurrence that they did not stop to weep long over their own dead children. The historian Lawrence Stone has argued, however, that in the early seventeenth century there developed what he has termed 'affective relations' between family members. According to Stone, from that date on something approximating the intensity of feeling that today's bereaved parents might experience became a feature of English family life.[2] It is certainly true that about this time an important series of funeral monuments was erected which praise boys for their erudition,[3] and stress the innocence of dead girls as examples to those who have survived. This is the image presented by John Dwight's remarkable stoneware figures (*c.* 1674) of his daughter Lydia (illus. 29, 30). The first is a portrait bust of the dead child shown in bed clutching a posy of flowers symbolizing her state of purity.[4] Her reward for her innocence is suggested in the idealized form of the second sculpture. Here she is shown with open eyes and draped in what some have seen as her shroud, but what is surely a version of an Antique, and therefore timeless, costume. Her hands are still clasped in prayer but now in a more animated pose, with a clear indication of an appeal heavenwards. At her feet there is a skull crowned with a wreath, and petals from her death posy are strewn around. In this second figure the choice of drapery

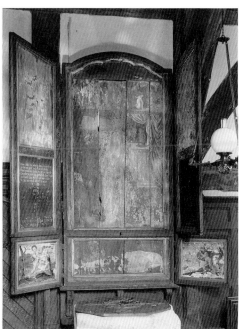

15, 16. (?)Melchior Salaboss, Monument to a member of the Harewell family, painted wood (restored), *c.* 1600. St Peter, Besford, Hereford and Worcester.

style and the pronounced *contrapposto* of the pose – one which gives a real swing to the hips – allows us to make sense of Robert Plot's allusions to famous ancient practitioners of 'the *Art Plastick*' in praise of Dwight. Plot was an antiquary, natural scientist and Dwight's fellow-member of the then recently founded Royal Society. The first image represents Lydia's 'natural' body and the second, idealized, image the innocent child's 'social' body, terms we shall encounter again in due course.

The damaged triptych from Besford, Hereford and Worcester (illus. 15,16), erected *c.* 1600 to commemorate a young member of the Harewell family, is in the older tradition of the *memento mori*. There are allusions to the child's natural body and to the innocence of infant purity, but the main didactic thrust is in the *vanitas* tradition. The outer doors of the triptych display the heraldic arms of the child's parents: Harewell, on the dexter side (to our left), and Colles. The upper part of the arched-top central panel shows the young child at his devotions in contemplation of the Last Judgment taking place over his head. Below him lies the, by now familiar, *transi* figure, shrouded in white. To the left and right there are more images of the *memento mori* and *vanitas* kind – Time, wielding his

scythe, and Death, poised with an arrow. Below them, symbols of the temporality of mundane beauty perish in an instant: to the left a child dances with a plucked rose and to the right he blows bubbles. These visual messages are supplemented by an extensive verse inscription which stresses the exemplary purity of the deceased, the final couplet reading:

> Blushe elder Sex from Christ to strai
> When suche an impe forshewes the waie.

This text would have been supplied at the request of the patrons to complement the paintings. The triptych is almost certainly the work of Melchior Salaboss, who signed the more ambitious Cornwall monument at nearby Burford, Shropshire, in the mid-1580s.

In the eighteenth century 'good' deaths were taken as subjects by painters with an academic training who were becoming increasingly familiar with the moralizing tradition of Continental history painting.[5] The pathetic but honourable 'dead soldier' in Joseph Wright's painting of that name was described by a contemporary connoisseur as especially moving because

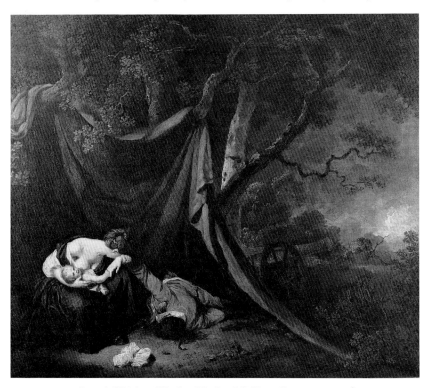

17. Joseph Wright of Derby, *The Dead Soldier*, oil on canvas, 1789.

it showed a tragic, contemporary event (illus. 17). Earlier in his career Wright had produced an exercise in the narrative tradition of the *Dance of Death* when, in 1774, he painted *The Old Man and Death* after a tale by Aesop and La Fontaine. This is an especially striking image because of the full daylight with which Wright floods the scene. Narratives of death set in the past, especially Antiquity, were believed to retain their didactic potency, as they could never be overtaken by fashion.[6] Wright's *Dead Soldier* illustrates a theme found in John Langthorne's *Country Justice* (1774–7), a poem in which Langthorne argued for the better treatment of rural vagrants. An impoverished family appears in Wright's picture, in which the figure of the mother acts as a pivot in a clever play of facial expressions. The face of the dead soldier is invisible to the spectator, while the mother's face is only partially seen, and the innocent child, taking his lips from his mother's breast, gazes out to enlist our sympathy. Its message is of the injustice and folly of a system and a state which exploits its soldiers without offering any means of repairing the damage to the social fabric caused by their deaths. Thus, as Langthorne puts it, all too often 'The child of misery [is] baptised in tears'.[7]

Not all 'good' deaths were fictional: biography could also be exemplary. Lady Venetia Digby's death came as a total shock. It happened one night early in May 1633 and left her husband completely distraught. He, however, saw the need for a permanent memorial and within two days Anthony van Dyck was at the death-bed sketching Lady Digby. His picture was delivered by 19 June (illus. 18).[8] Van Dyck was familiar with her features because he had painted Lady Digby as Prudence earlier that year. John Aubrey, writing a generation or so later, records that Sir Kenelm also had 'her hands cast in playster, and her feet and Face . . .'; he also had himself portrayed by Van Dyck in mourning dress.

Van Dyck succeeded in creating an extraordinarily powerful depiction of what we might term Lady Digby's 'monumental' body. Sir Kenelm Digby described how the artist 'brought a little seeming color into her pale cheeks' by 'rubbing her face', and he claimed that Van Dyck 'hath altered or added nothing about it'. Yet the image clearly denies the unpleasant processes that death must have been having on the natural body. Seen from a strikingly high viewpoint, the corpse has been arranged as if sleeping, and a modest allusion to mortality and natural beauty is suggested by the rose sprig which has fallen from her hand. Sir Kenelm described this device as 'a fitt Embleme to express the state her bodie then was in'. So the picture is an idealization and not simply a standard rendering of wifely virtues. It does, however, record how, over the eight years of their

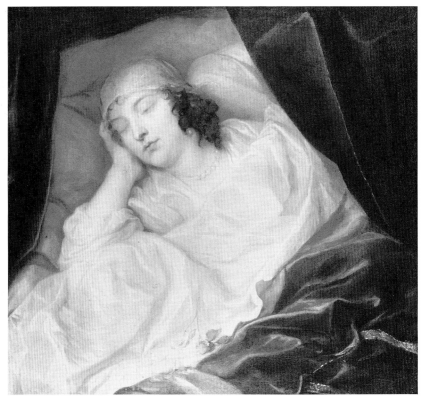

18. Anthony van Dyck, *Venetia Digby on her Deathbed*,
oil on canvas, 1633.

marriage, Venetia Vernon, 'a most beautifull desireable Creature' coveted by many of the 'young Sparkes of that time', had been transformed into Lady Venetia Digby, a paragon of female virtue. Sir Kenelm had faced parental objections to the match but had claimed that 'a wise man, and lusty [that is, himself], could make a honest woman out of a Brothell-house'.

In his mourning, Sir Kenelm Digby became a scholar-hermit at Gresham's College, and used the idealized portrait to retain a memory of his late wife. He kept it with him always, and moved it around his apartment: 'When I goe into my chamber I sett it close by my beds side, and by the faint light of candle, me thinkes I see her dead indeed; for that maketh painted colors looke more pale and ghastly than they doe by daylight'. The idealized image of the dead woman, shown as if asleep, undoubtedly helped protect her husband from the shock of her death. One year later, in May 1634, he came to an arrangement with the London parish of Christ

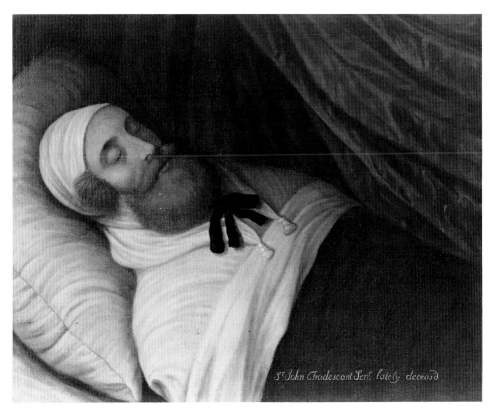

S.ʳ John Tradescant Sen.ʳ lately deceasd

19. *John Tradescant the elder on his Deathbed*,
oil on canvas, *c.* 1638.

Church, Newgate Street, for a permanent monument to be erected there to her memory. The monument was lost in the Great Fire of 1666, but seems to have displayed a gilt-bronze portrait bust, a version of which included the inscription 'Uxorem Vivam Amare, Voluptas Est: Defunctam, Religio' ('The pleasure is in loving a living wife; the dead one, I revere').

By comparison, the picture of John Tradescant the elder on his deathbed seems innocent of artifice (illus. 19). The great gardener, plant-hunter and traveller, the man who introduced lilac and acacia into England, is shown in a state close to Nature. His natural body is wrapped in its shroud in readiness for the coffin. Tradescant's monument in the churchyard at St Mary's, Lambeth, London, was intended to be a more specific replacement for him; it takes the form of a sarcophagus decorated with imaged references to Tradescant's career as a botanist and traveller, including trees, a crocodile and exotic buildings.

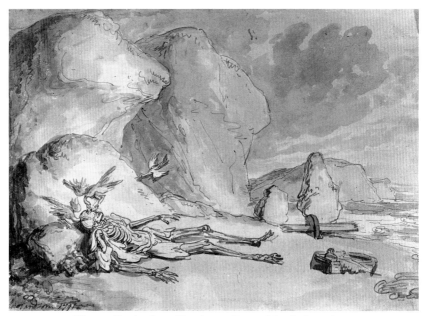

20. Thomas Rowlandson, 'Death on a Desert Island', from the series
Dreadful Deaths, pencil and watercolour, 1791.

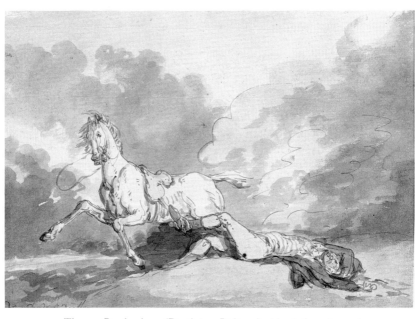

21. Thomas Rowlandson, 'Death in a Riding Accident', from the series
Dreadful Deaths, pencil and watercolour, 1791.

VI · DEATH, A BAD BUSINESS

By the same token, pictures helped point out the dangers of 'bad' deaths. Deaths by accident which left the body lost and thus never buried were of special concern. The full horror of this image is recorded by Rowlandson in two late-eighteenth-century watercolours (illus. 20, 21). In one the artist has concentrated on death by ship-wreck and starvation. The skeleton, stripped of its flesh but not yet of all its ragged costume, suffers the final indignity of losing its brains to the beaks of a flock of scavenging birds – an allegory of Reason subjected to Nature. In the other, the unfortunate victim is shown against a threatening sky being dragged on his back by one stirrup after an accident in a hill-top gallop. Other bad deaths included suicides – such as Reynolds's mock-heroic *Dido* (illus. 22)[1] – deaths in duels or by assassination – such as the Darnley memorial pictures by the otherwise unknown Levinus Vogelarius – or, worst of all, the death of the unbeliever, as imagined by Blake.

In his illustration to Robert Blair's *The Grave*, showing *The Death of the Strong, Wicked Man* (illus. 23), the division of the person is between the

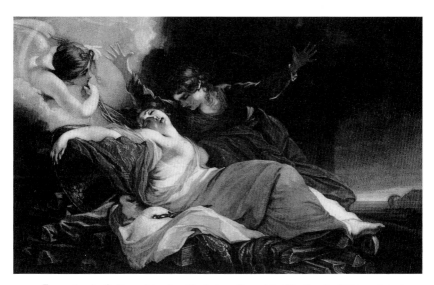

22. Engraving by S. Reynolds after Sir Joshua Reynolds, *The Death of Dido*, original composition 1781.

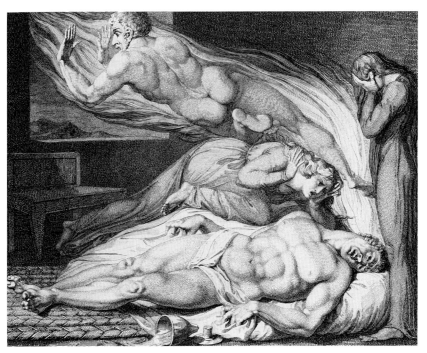

23. Etching by Schiavonetti after William Blake, 'The Death of the Strong, Wicked Man', illustrating Robert Blair's *The Grave*, 1805.

physical body – relatively more naturalistic in its treatment – and the spiritual body or soul, which occupies space and obeys laws of physics unknown in the mundane world. The Wicked Man is seen undergoing the agony of his death throes: the extremities of his limbs are contorted, his spine is arched and his head is thrown backwards. Alongside are symbols of disruption and fragility: an upset cup and a candle caught in a draught. From the bolster another blast of wind rises up and then out of the room, carrying with it a second version of the Wicked Man's body, in its ideal, nude state. The soul, able to foresee its damned fate, puts up two hands in an attempt to resist the future and twists past two draped female figures (both living and, presumably, virtuous) who separately express two of the standard reactions to a 'bad' death – grief and anger. Blake's type of dual image of the body and soul was well established in Western iconography and illustrates, once more, the continued presence of multiple images of deceased individuals in post-Reformation England.[2]

Some of the features of Blake's design are found in a much simpler image on the same subject, Francis Hayman's *The Bad Man at the Hour of*

his Death (illus. 24), known only from engraved versions published in the 1780s and an interesting pair of preliminary working drawings on a sheet in Budapest.[3] Again, the dying man twists his body uncomfortably and puts his hands up in an attempt to fend off Death's spear. Among the volumes on the shelves behind him we can just make out the spine of a copy of Gilbert Burnet's *The Life and Death of the . . . Earl of Rochester*. Burnet's biography describes what is probably the most famous case in literature of the didactic potential of the death-bed conversion – that is, the unbelieving sinner brought round to a state of true repentance. It reveals that even an avowed disbeliever starts the process of 'dying' well

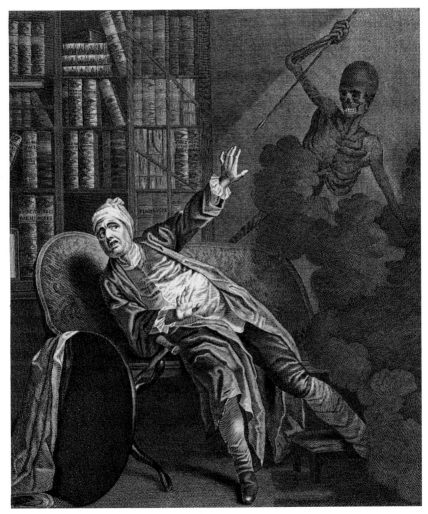

24. After Francis Hayman, *The Bad Man at the Hour of his Death*, first published 1783.

before the moment that the natural body dies. Rochester, who had some knowledge of medicine, realized his condition was fatal and quickly appraised Burnet of his 'Death-Bed Repentance'. Once the process of repentance was complete, Rochester, by now spiritually whole, expressed no wish to recover from his physical illness but wished only to move forward to the next stage of 'dying', that is, the death of the natural body. As an experienced transgressor and as a result of his metaphysical exercises, Rochester knew that no further sins could be committed by the soul once it was released from the constraints of the body.[4]

The idea of 'dying' as a process which neither the sufferer nor society can or should stop is one which anthropologists have found particularly fascinating. In certain cultures people who have disappeared from a community, for whatever reason, may be declared dead by ritual, and later, when they wish to return, find that reintegration is illegal.[5] For example, a husband lost for many years and ritually 'buried' may not be re-accepted even when he finds his way home: as far as his society is concerned the death process has started and may not be reversed. In a similar vein, in a niche in the Holy Trinity Chapel of Wimborne Minster, Dorset, there is a wooden box decorated with heraldry, inscriptions and a date. This is known as the coffin of a local lawyer, Anthony Ettricke, who, having fallen out with the Minster congregation and having vowed that he would never be buried within or without the church and neither below nor above the ground, got round his pledge by having a recess made in the wall. So convinced was Ettricke that he would die in 1693 that he had the coffin dated accordingly; his subsequent amendment to '1703' remains visible.

In post-Reformation England the Church was not the only institution concerned with the organization of the death ritual: the state also played a prominent regulatory role in behaviour through the instruments of the law. Paintings, such as the portrait of *Thomas Braithwaite* (illus. 27), recorded the making of a will, a grave occasion instituted by the state to prevent the potential fragmentation of the bodies politic and economic caused by the deaths of individuals. In this remarkable scene the subject is shown pallid and drawn, propped up in his bed. Above his head an epitaph records that 'Thomas Braithwaite of gentry stock, died 22 December, 1607, aged 31'. To Braithwaite's left a paper is presented to him on which are written the words 'In you, O God, he hoped; in you did he not despair; In you, O God, he was victorious, he wrote his last . . .'. Around the dying man's head, inscribed on the very pillows supporting his expiring body, are other Biblical texts – one rendered in Latin, French and English: 'However it be, yet God is good to Israel: Yea to those which are pure in heart'.

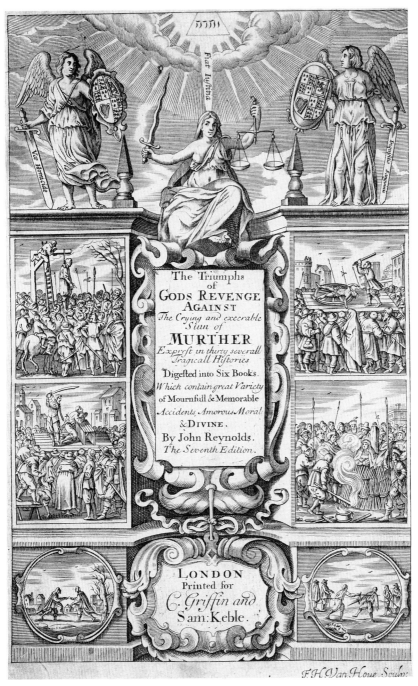

25. Frederick Hendrick H. van Hove, Engraved title-page for John Reynolds's *The Triumphs of Gods Revenge Against . . . Murder*, London, 1704.

Laws relating to wills affected all propertied people, but other laws were passed which condemned the bodies of those found guilty of capital offences to mutilation and dismemberment as well as execution. These were terrifying punishments to all believers in the resurrection of the body (illus. 25). Under a statute of Edward VI's reign, peers were allowed to die more swiftly – by beheading – even when their crime was treason.[6] We can now understand how capital punishment could exceed the killing of the victim. It also helps explain the behaviour of the avenging monarchists at the Restoration who disinterred the bodies of Cromwell and other regicides and subjected them to ritual execution.[7] By the same token, great care was taken to publicize and proclaim the deaths of the great, praising their memory but emphasizing the continuity of the *status quo*.

Two remarkable plaster casts preserved in the Royal Academy, London, record how the bodies of criminals were flayed, posed and turned into models for young artists (illus. 26).[8] Engravings by Hogarth, such as the

26. 'Mr Legge', plaster,
cast from a flayed corpse.

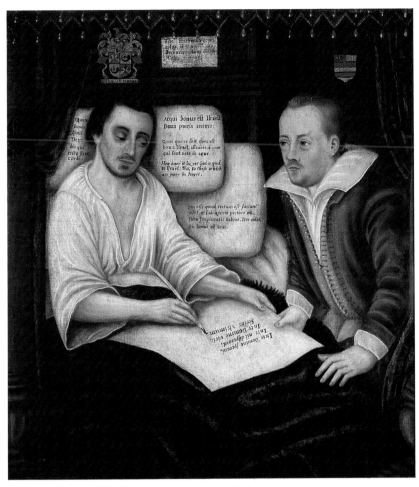

27. *Thomas Braithwaite making his Will*, oil on canvas, 1607.

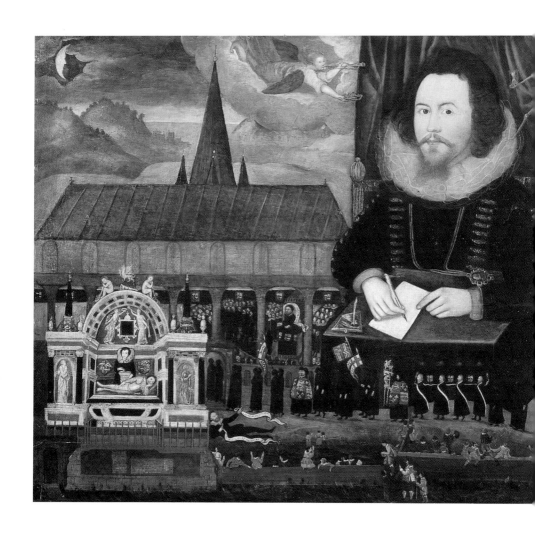

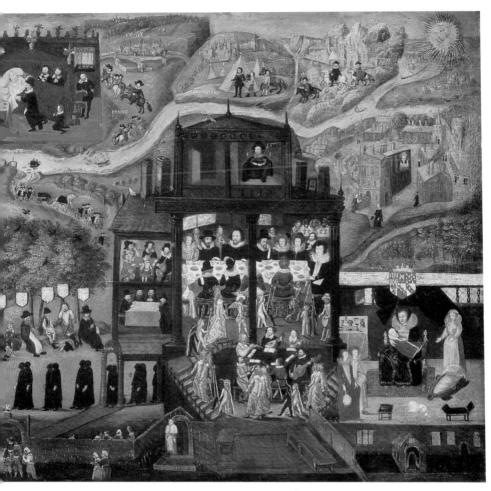

28. *The Unton Memorial* picture, oil on panel, after 1596.

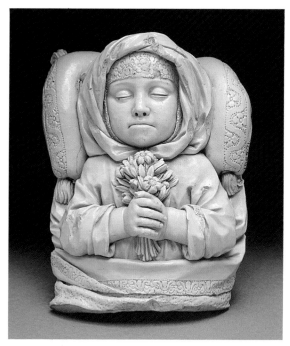

29. John Dwight, 'Lydia Dwight on her Deathbed', stoneware, *c.* 1674.

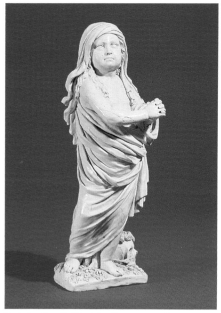

30. John Dwight, 'Lydia Dwight Resurrected', stoneware, *c.* 1674.

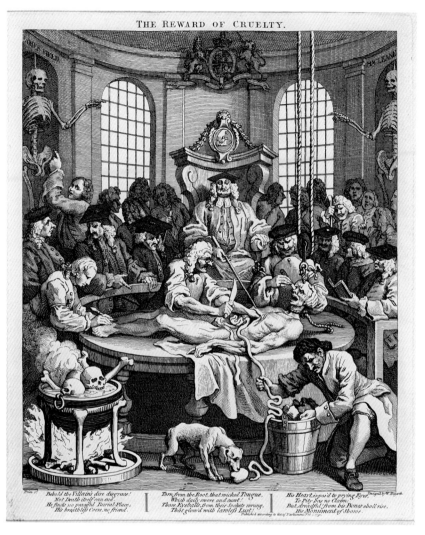

Behold the Villain's dire disgrace!
Not Death itself can end.
He finds no peaceful Burial-Place,
His breathless Corse, no friend.

Torn from the Root, that wicked Tongue,
Which daily swore and curst!
Those Eyeballs from their Sockets wrung,
That glow'd with lawless Lust!

His Heart expos'd to prying Eyes,
To Pity has no Claim;
But, dreadful! from his Bones shall rise,
His Monument of Shame.

31. William Hogarth, 'The Reward of Cruelty', from *The Four Stages
of Cruelty*, engraving, 1751.

final scenes from the cycles *The Four Stages of Cruelty* (illus 31) and *Industry
and Idleness* (illus. 32), show the strong didactic link forged between the
state's control over the convicted body and the preservation of moral and
legal order. Although public executions were viewed with increasing
scepticism and were often the focus of mob violence in the eighteenth
century, there was an instructive theory behind them. A priest was brought
in to lecture the wrongdoer, who would then make a public declaration of

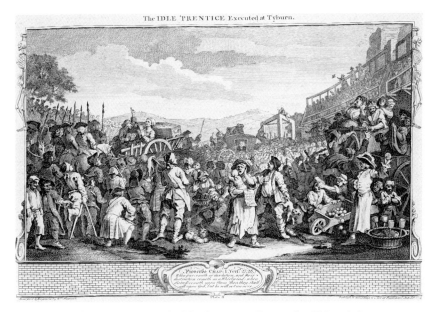

32. William Hogarth, 'The Idle Apprentice Executed at Tyburn', from *Industry and Idleness*, etching with engraving, 1747.

guilt and exhort others not to follow him or her down the path of sinfulness.[9] Contemporary illustrations of such scenes often show victims already dressed in a shroud, while as far as the state was concerned death had already taken them. The manner of dying becomes a monument to the memory of the deceased.

VII · TWO BODIES

The main functions of the commemorative monumental body were to resist the inevitable process of decay which overtakes the corpse and to deny the ephemerality of the ritual spectacle of the funeral. In late medieval England the decay of the corpse was sometimes a subject in funerary art in the form of the *transi*, that is a representation of a corpse often made more horrifying by being shown crawling with toads, lizards, snakes, snails and other creatures redolent of decomposition and sin.[1] Such images of the natural body were intended to act as potent reminders of the mortality

of the onlooker, but they were often juxtaposed with another representation, that of the deceased in full control of his or her social faculties.[2]

This binary image of the natural and the social illustrates a principle which was of central importance to the visual culture of the post-Reformation death ritual. Not only was dying an unstable moment set between the two key stages in human experience – life and death – but with regard to the theory of death, human beings themselves were not seen as unities. Religious teaching had established a separation of the body and the soul and, in an adaptation of the medieval theory of the 'King's Two Bodies', there seems to have been a distinction between what modern thinkers would term on the one side the natural and on the other the nurtured or socialised.[3] The natural body after death was simply the corporeal remains which had to be removed or treated to contain the inevitability of decay. It was regarded as a source of danger, not so much to public health – as was to become the main concern in the nineteenth century – but rather to the health of the public body whose dignity and immaculate memory could so easily be damaged. In the process of dying, the death of the natural body was followed by efforts to preserve the social body as an element in the collective memory. Today this function is usually undertaken by photographs, but the visual culture of post-Reformation England also established and preserved the social body.

One of the best-known of all seventeenth-century paintings by a native artist is John Souch's *Sir Thomas Aston at the Deathbed of his Wife* (illus. 33). This picture has been misunderstood by commentators unaware of the theory of the multiple bodies. This theory, together with the inscriptions, clarifies both the narrative and other iconographic details of Souch's picture, part of which shows Magdalene Aston's corpse and the bed-chamber where she had died in childbirth on 2 June 1635. She appears again towards the bottom of the picture in the social space of the living, in the company of a representation of her husband and their eldest son Thomas (who was himself to die prematurely in 1637). The picture shows both the natural and the social body of Magdalene Aston. Various objects are placed in the bed-chamber, most prominently a cradle draped in black. There are also Latin inscriptions and a coat-of-arms. Souch's theme is the command that death has over the natural body, in contrast with the survival of the soul and the way the body at death can manifest virtue. Magdalene's two bodies occupy the right-hand side of the room; the dead baby is represented by the skull and draped cradle; all three living members of the family are in mourning and the living son is encouraged to contemplate the traditional message of the *memento mori* by means of symbols of

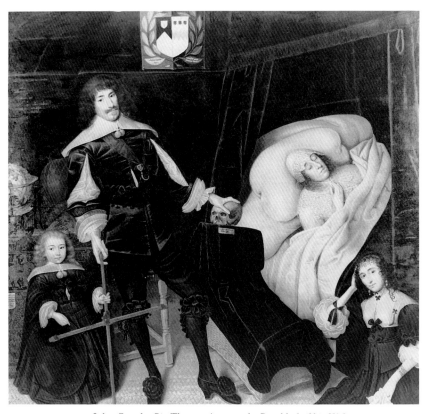

33. John Souch, *Sir Thomas Aston at the Deathbed of his Wife*,
oil on panel, 1635–6.

mundane existence – the globe, the cross-staff with which to survey the world, and the lute, the strings of which can snap as suddenly as death can strike.

As commemorative art will also show, funeral monuments were concerned with establishing a permanent image of the social body. The monumental effigy sets for eternity the image of the deceased, it preserves his or her social body and it is happy to mislead the viewer about the whereabouts of the 'natural' side of the equation. The famous cry 'The king [natural] is dead; long live the king! [political]' is a reminder of how widespread these distinctions were.

All the artefacts produced as part of the English death ritual can be more easily understood if we accept that the bodies of those commemorated were imagined in diverse ways. The natural body comprising the biological matter is one of its aspects; the social body, that is the individual's place

in society, is another. Both ritual and artefacts tend to focus on the balance between these two states. The visual objects here discussed show the way in which the ritual was developed to satisfy the requirements of civilized behaviour, to dispose of the corpse with a due regard for feelings, and to help the culture take the steps necessary to safeguard the social fabric, thus resisting the challenge that individual deaths made to the well-being of the community or even of the state.

VIII · BODY LANGUAGE

In early modern England, the inheritance laws were such that to die with no male heir and many heiresses could be disastrous at all social and economic levels.[1] The need for social cohesion and continuity in the face of the disruption which resulted from death – especially from the death of someone like a peer of the realm or a great landowner – was met by the theory of the Two Bodies. This assumes that humankind and its works are complex and problematic, especially at moments of crisis and tension, such as those focused in the death ritual, and can shed light on the changes in social relations signifying that a death has occurred.

Many have observed that a consciousness of death is, like verbal language, unique to humankind;[2] and, perhaps not surprisingly, to consider how meaning is credited to language illuminates the natural and social aspects of the body at death. To explore this we have to turn to theorists of language who have taken seriously its artificiality.

If language is not only a human invention but also the very means of thought, there is clearly a problem in describing its artificiality, as there must be too in proposing how meanings develop in language. One famous answer was made by Ferdinand de Saussure (1857–1913), a Swiss professor of linguistics, who proposed, in an insight of breathtaking simplicity, that we simply take the component parts of verbal languages – words – as signs or conventions, rather than as expressions of what we might call 'natural' meaning.[3] The way Saussure demonstrated the working of words as verbal signs was by asking us to think of such signs as having two aspects. The first was the bearer of the meaning, the acoustic charge of a word uttered orally, or the visual configuration of writing. This first aspect,

which Saussure termed the *signifier*, has a relation with the *signified*, its meaning. This, he argued, was purely arbitrary, the result of convention, an agreement between the human parties involved in using it. There is nothing very exciting in this description of the basic rules of what has come to be called semiotics, until we study the circumstances in which that agreement about conventional meaning is reached; it is, of course, the social arena of human work and endeavour. Conventions are not set up in response to neutral conditions but result from the whole wide range of pressures which typify the human condition: pressures based on sex, gender, class, age, history, the weather, power relations, habits, ideology and so on. The conceptualized space between the signifier and its signified is likened to an electrical relay through which socialized data may pass.

In the theories of Saussure and his followers the artificiality of that relation between the signifier and its signified demonstrates the social basis of language's meanings. On a simple level, linguisticians can easily show how a language develops in response to the particular social conditions in which its signifieds are deployed and, as a corollary, to show that sense and behaviour can be directly influenced. The Inuit tribes of the Arctic not only have dozens of words for the shades of white which surround them but, some would argue, can only see those different colours because of the subtleties of meaning available in their language.

One of the most important and controversial intellectual developments of this century has been the attempt – pursued by practitioners of the human sciences on many parallel fronts – to apply Saussure's perception about the nature of the linguistic sign to other fields of human endeavour. The signified acquires definition through a process which concentrates on individual signs in relation to a whole system rather than the piecemeal equivalents that occur in an unsubtle bi-lingual dictionary. By comparing signs with other signs within their system or structure, meaning is determined by a process which has provided this whole intellectual movement with its name: Structuralism.[4] This Structuralist approach assumes that all meanings in human semiotics are artificial and, therefore, reducible to a social analysis. To achieve the best results, this should proceed by defining that which is not signified by a sign to that which is. For example, the easiest way to establish what 'female' means within a certain cultural situation may be by defining its supposed opposite, 'male'. By this theory, clarity of definition is achieved through a clear understanding of 'the other' to the sign in question, an approach which has proved especially fruitful in cultural analyses where questions about race and gender have been asked.

Most famously, the Structuralist model has been applied in the field of anthropology, and most importantly by the French scholar Claude Lévi-Strauss,[5] whose moving collection of essays, *Tristes Tropiques* (1955), contains a chapter entitled 'The Living and the Dead'.[6] In this sequence of quite casual observations, Lévi-Strauss notes that relations between the living and the dead in twentieth-century Europe depend on a structural opposition between the 'good' deaths of those who have succumbed through natural causes and the 'bad' deaths of those who have been murdered, been bewitched or taken their own lives. Despite the European dead being generally regarded as what Lévi-Strauss calls 'apathetic and anonymous', the 'good' dead of most cultures form a benign corps of ancestors while their 'bad' counterparts can become evil spirits. In our culture, fewer and fewer deaths are identified as 'bad' enough to achieve these results: even complete outsiders – terrorists, for example – are accorded humane burial. In general, in the domain of the public and in terms of ritualized response, death is treated largely with indifference.

Students of systems of non-linguistic signs have also attempted to adapt models like Saussure's to their own material.[7] A famous scheme which distinguished three types of visual sign – the icon, the symbol and the index – was developed early in this century by the American philosopher E. Peirce.[8] A portrait would be an example of the first type of sign, recognizable because of a visual resemblance to the motif it represents. The second stands in for the motif, for example a dove to represent the Holy Spirit. The third is a kind of sign which refers to the existence of the motif, as a weather-vane shows the strength and direction of a breeze.

We can adapt the terms of the Structuralists and, by analogy with Saussure's thoughts on language, analyse the human body at death as 'a sign' with two aspects, the shifting relations between which determine its meaning. As in any analysis of human behaviour, we have to start with the signifier, the bearer of meaning. In the case of the death ritual this would appear to be the natural body, with which the social body acts as its signified, achieved, in turn, by a whole world of other signifiers, such as costume and heraldry. The rich visual culture of the post-Reformation English death ritual shows time and again how, at the moment of death, the relationship between these two aspects of the sign is arbitrary. With death, the signified is released from the comparative restraint of the signifying natural body, a process illustrated by figural sculpture on monuments: soldiers become Roman heroes, male politicians become statesmen, wives and mothers become paragons of virtue, according to models created deep within patriarchy.

34. Dr Southwood Smith and Jacques Talisch, The Auto-Icon of Jeremy Bentham, natural materials, wax and textiles, 1832; restored 1981.

Using Peirce's system to analyse the art of death, the body portrayed does not constitute a simple iconic sign of the individual. In fact his scheme seems too crude, for it is hard to imagine any portrait as thoroughly iconic. The *transi* figures of the rotting natural body that we have been considering as part of the *memento mori* tradition are not accurate naturalistic portraits; neither, as will become clear in due course, are monumental effigies. Evidently, the two aspects of the body at death are related in a way which becomes increasingly arbitrary with the passing of time. The 'natural' features of the deceased may have some value in the ritual but are rapidly replaced by an image built around the social body. Just what is signified by the social body changes according to the cultural pattern in which the sign, the body after death, is first deployed. The social theorist and advocate of Utilitarianism, Jeremy Bentham (1748–1832), registered his anxiety over the increasingly arbitrary relation between the two aspects of the body in arguing that auto-icons (illus. 34), figures made from the very bones of the deceased, would in time supersede the necessity for sculpture.[9]

Bentham set out his views on the fate of the natural body several times during his long life and left his corpse for transformation into the extraordinary image still preserved at University College, London. In an unpublished fragmentary pamphlet of *c.* 1832, the year of his death, he addressed himself to the auto-icon specifically, and followed the Puritan moralists of the immediate post-Reformation period by pointing to the deceased natural body as a source of disease and the expense of a funeral as a waste of money. The auto-icon would avoid such moral pitfalls by displaying a kind of neutralized natural body which would become the social body, and retard the process whereby the two aspects of the body at death tend to drift apart. Auto-icons would be displayed with traditional regard for the moralizing potential of the social body in its monumental form: Bentham envisaged temples of fame (and of infamy) peopled by auto-icons, rather than by carved statues or the collections of waxworks which were becoming increasingly popular in Europe around 1800 and still pack in the crowds at Madame Tussaud's in London. Avenues of auto-icons could decorate ancestral estates; groups of them in conversation might be used in tableaux or historical displays in theatres. Bentham thought 'every man [*sic*] may be his own statue' but, despite the fame of his own image, the idea never caught on. As Ruth Richardson has re-marked, anxiety over the natural body's fate has never entirely subsided.[10] When, after a tragic accident, the body cannot be discovered, its absence becomes a focus for anxiety and delays the process of effective mourning.[11]

IX · THE NATURAL BODY AND ITS FATE

After death the natural body was accorded a programme of treatment, but even here the objective of the ritual was the survival and re-presentation of the social body rather than the conservation of the natural body *per se*. In order that the burial itself could effectively mark transition – the points between death and life, horizontal and vertical, above and below the earth – the body could not simply be left to the bacteria. To prevent a distasteful display of repulsive decay, the natural body could be subjected to a process of temporary preservation through embalming, which delayed internal corruption. Funerals of powerful people demanded such an elaborate ritual that considerable time had to be set aside to make the necessary arrangements. Sometimes there were great distances between the places of decease and interment. One of the most important aims of the funeral and of the subsequent construction of a permanent commemorative image was, as suggested above, the preservation of social cohesion and the denial that any one individual death presented an irreparable threat to continuity. The ritual, therefore, included the replication in wax of the face or the hands so that a convincing version of the natural body might be displayed at the funeral. From the sixteenth century English artists were employed to take face-masks of the great, the good and, sometimes, the notorious – royalty, Isaac Newton, Cromwell (illus. 35) – a process which required skill in several media and an understanding of a technique which must have been close to that described in a famous text, written *c.* 1400, by the Florentine master Cennino Cennini.[1]. Cennino was especially interested in the particular problems set for an artist required to take a life-mask of an important person. Specially prepared breathing tubes were needed for the subject and the plaster had to be mixed with rose water. Death-masks must have been more straightforward: the body was laid out and a collar placed over the face to restrain the plaster until it set.

In certain cases – usually for political or logistic reasons – funerals took such a long time to arrange that the natural body could no longer safely and decorously participate. For the ceremony itself an effigy had then to be made to represent the natural body, unchanged, unblemished in alliance with its signified, the social body. The royal accounts consistently note the payments made in relation to these figures, some of which have survived

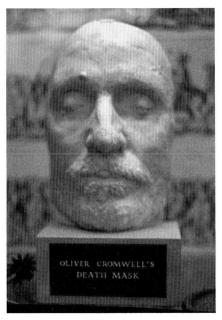

35. Death Mask of Oliver Cromwell, plaster, 1658.

at Westminster Abbey.[2] Various materials seem to have been used: a wooden armature – not unlike a tailor's 'dummy' – packed round with straw and plaster and enclosed with sacking or leather, and with details such as heads and hands in wax or wood then attached. The work was undertaken by artisans of various kinds employed by, or on the fringes of, the royal household. John Colt was paid £50 for the 'Image rep[re]senting his Late Maiestie' carried at the funeral of Elizabeth I on 28 April 1603. Colt was the brother of Maximilian Colt, the stonecarver who made Elizabeth's monument and who seems, like many Elizabethan artists, to have been proficient in a range of trades.[3]

The effigies were intended to achieve the most striking realism possible: Henry VIII's effigy was 'made veray like unto the Kings Ma[jes]tis person',[4] while that made for the funeral of Henry, Prince of Wales, in 1612 had arms and legs which 'moved to sundrie accions' (illus. 36).[5] When Edmund Sheffield, 2nd Duke of Buckingham, died on the course of a Grand Tour in October 1735 he was sealed in lead, and a replica made in wax, leather, wood and fibrous stuffing bore his ceremonial costume at the state funeral in London (illus. 50). The realism of this extraordinary image demonstrates its role as a replacement for the natural body. As we shall see, the social body as represented in commemorative art was generally idealized.

36. Richard Gaywood, 'The Funeral Effigy and Hearse of Henry, Prince of Wales',
etching and engraving, from Francis Sandford, *A Genealogical History of
the Kings and Queens of England*, 1707.

The next stage was the construction, decoration and labelling of a coffin
or other satisfactory receptacle for the natural body on its journey to the
grave. These artefacts had to be designed and produced, sometimes at
very short notice, with due regard to the needs of continuity, differentiation
and stratification.[6]

One aspect of the increasing arbitrariness of the relations between the
social and natural bodies was the steps taken within the state-sanctioned
death ritual to preserve social differentiation: each class had to be treated
by distinct and appropriate rituals. A long tradition was that the state
legislated for a treatment so harsh of the natural body of capital offenders
that their eternal soul could be damned as a consequence, for judicial

dismemberment of the body was thought to deny the possibility of resurrection at the Day of Judgement. Such laws demonstrated that there was indeed such a thing as a fate worse than death. As Ruth Richardson has shown, the last stage of this process came with the passing of the Anatomy Act of 1831, which treated the bodies of the poor in ways that had previously been the fate of the bodies of criminals: they were turned over to the anatomists for dissection. In terms of resurrection, this practice was little different from beheading.[7] Whatever preachers may have claimed, the popular death ritual was underpinned by a strong assumption that the soul and the body were linked and even indivisible. The widespread fear of 'death on the parish', that is, in the work-house, followed this Act. As we have seen, our current bipartite model of death/life is much too crude to explain the whole gamut of human reactions in the historical past to dying.

With the development of an ever more complex capitalist economy in eighteenth-century England, the visual culture produced to accompany the decaying remains of the natural body to its final resting place became more and more subtly differentiated. Coffins and their furnishings were designed to satisfy a greater range of tastes and to suit a wider variety of socio-economic levels (illus. 37). Die-stamped processes permitted the manufacture of cheaper versions of prestigious and, hitherto, exclusive designs (illus. 38). The ironmonger's pattern-books brought designer funerals to the masses and threatened the very principle of differentiation. There are valuable examples of such catalogues in the V & A, one of which was produced by a coffin furniture and ironmongery warehouse at Borough in Southwark, and suggests a date of 1783 (illus. 39). Southwark had for some time been a centre of production of items for the funerary and commemorative trades. The range of furnishings in this catalogue is remarkable and includes complex double, triple and even quadruple page, engraved pull-out spreads. Details of size, price and qualities of materials are given throughout. Among the standard items are specimens of lettering of various forms, coffin breast-plates for children, different kinds of handles and pulls, and various kinds of decorative items – vases of flowers, cherubs, crucifixes with skulls at their feet and decorative edging known as 'coffin lace'. Many of the symbols, sentiments and captions on this metalwork are very similar to the decorative motifs which we shall encounter on funeral invitations. In this set of late-eighteenth-century images, however, Death himself, the indiscriminate scourge of humankind, does not appear. The concentration is very much on the sense of loss, the hoped-for resurrection and the precise identification of the deceased.

37. Coffin Furniture: A gilt-brass masonic grip-plate. *c.* 1790; stamped iron (formerly gilt) cartouche, 1760s. 38. Patent die-stamped coffin furniture, stamped iron gilt, 1839. 39. Page from Tuesby & Cooper's wholesale catalogue for their coffin furniture and ironmongery warehouse, *c.* 1783.

Death came universally, and of material possession the poets had long observed that 'you can't take it with you':

> If none can 'scape death's dreadful dart,
> If rich and poor his beck obey . . .[8]

The implication of such even-handed treatment was profoundly damaging to the social fabric. The ritual thus demanded that social bodies after death had to be differentiated one from another; a task which was mainly the responsibility of the monumental body.

There was also, however, the funeral itself, which in both its secular and ecclesiastical aspects was designed to manage the death of the individual so that the natural body would be piously dispensed with as well as the social order maintained. The body was, after all, simply a temporary housing for the soul. The paraphernalia produced for the ceremony had therefore to be both utilitarian and symbolic in the sacramental sense. Some parishes were equipped with a public coffin which carried the poor on their last journey to the graveside and was then returned to the church.[9] Priests taught that the poor, as well as the mighty, could set an example in life and in death, a message confirmed in the woodcuts of innumerable cheap broadsheets, such as *The Cry of the Poor Man* of 1596.[10] The virtue of the poor was exemplified by modest expectations of the afterlife – spiritual preparation and a decent funeral. In Hampshire and elsewhere parishioners made crowns from wood and paper to be carried before the coffins of local virgins (illus. 40).[11] These were made to hang in the church as a challenge to any imputation against the purity of the deceased. Once the proper period had elapsed, they were hung from the rafters to act as a continuing symbol of virtue.

40. Virgin's Crown (or Maiden's Garland),
traditional design in wood and paper, late 18th century.

X · FUNERALS: THE
DECLARATION OF DIFFERENCE

The ritual of the Virgin's Crown was an opportunity for the lower orders to be displayed as examples of virtue and, indeed, questions of social class were frequently raised by its third stage, the funeral.[1] The objects prepared for it had a very clear function: they were designed to display and reinforce the social distinctions of the dead. In cases where the funeral related to the deaths of the high and the mighty, the whole show was orchestrated by heralds, with the emphasis very much on the preservation of the social body. The natural body, treated by the embalmer or perhaps even buried already, was no longer the object of attention; the burial might even have preceded the funeral by some months.[2] Top families organized heraldic funerals entirely on the basis of rank to deny the challenge to the continuity of the social body. In such cases, individuality, in the sense of personality or character, was of little significance: the funeral commemorated the person who had filled a certain rank. A similar practice was employed in the choice of mourners; Randle Holme lists 'the number of m[o]urners at funeralls according to the degree & estate of the defunnct' whatever their personal relation to the deceased: 'It[em] Kinge to have murners – xv; It[em] Queene or a Prince – xiii'.[3] The appropriateness of particular potential mourners was gauged by matching their rank and sex with that of the deceased. In Paul Sandby's sketch showing the funeral of a young woman, the pall is held publicly by female hands while the work of carrying the coffin is, in fact, being done by the men whose legs are also just visible (illus. 41). Such was the power of this convention, that those genuinely moved by the loss of a close relative might well find themselves completely excluded from any participation in the public funeral.

So potentially disruptive were the deaths of the great that the state made sure that their funerals were arranged with due recognition of questions of degree. In such cases, the cultural practice was shaped by legislation and royal decree. There were many street events in early modern England and among them the funerals of the great were, clearly, deeply memorable occasions which helped construct and reconstruct the complex patterns of social experience. For the nobility, the fellowship of the College of Heralds laid down numbers of mourners and types of armorial display and warned off upstarts among the lesser orders. Augustine Vincent, Rouge Croix

41. Paul Sandby, *Pall-Bearers accompanying the Coffin at a
Spinster's Funeral*, pencil, before 1777.

Pursuivant from 1621, established special rules about the size of hearse
allowed each rank.[4]

In addition to the rules imposed on the great and the powerful, there
were sumptuary laws which controlled the clothing that people were
allowed to wear and the constant vigilance of peer-group control. In 1618
this control was formally extended to cover permanent commemorative
art, for it had become clear that the extensive use of heraldry on monuments
could not be left to non-professionals.[5] The result of this was the pro-
duction of a small number of exquisite illuminated drawings submitted by
the tomb-makers as permanent records of coats-of-arms on tombs; how-
ever, not many seem to have taken any great notice of the decree (illus. 42).

It is significant that the heralds were those made responsible for this
important aspect of social policy. The science they practised was a late
medieval invention,[6] which employed visual signs in symbolic ways to
identify individual members of families and indicate their rank. In an
hierarchical society and with the levels of degree carefully distinguished,
the heralds symbolized the stability and order of the state. They were
appointed by royal decree, their College was founded under the Tudors
(in 1555) as an act of centralized control and their authority depended
finally on the very person of the prince. Throughout the later sixteenth
century, at the same time that heralds' martial responsibilities were becom-

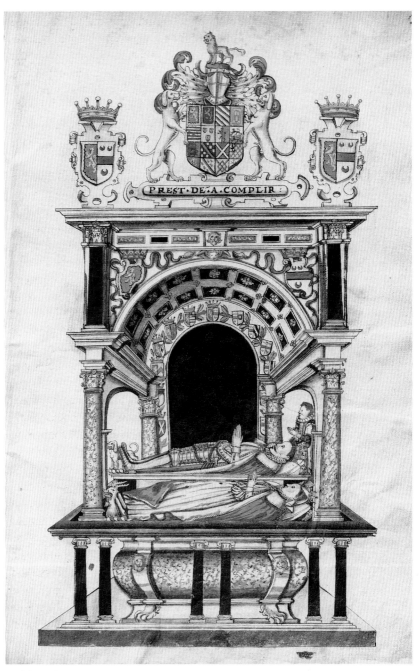

42. Maximilian Colt, Drawing in pen, ink and watercolour of the Monument to Edward Talbot, Earl of Shrewsbury, from *The Book of Monuments*, 1619.

ing less and less important, their symbolic and ceremonial brief was expanding. Heralds controlled, indeed organized, noble and state funerals, and their authority lay partly in their capacity to lay down rules about the complex visual culture which had to be produced on such occasions. For lesser funerals the controls were more subtle but no less effective: precedent, custom and codes of bonding all acted to preserve differentiation. So, of course, did cost: 'blakes and funeral charges' could be astonishingly expensive. Lord Keeper Bacon left directions that required his executors to spend £919 12s 1d on his funeral in 1579.[7]

The justification for such expenditure was that funerals re-applied the rules of life after the death of the natural body: as was argued by contemporary Puritan divines, funerals 'rather comfort the living than help the dead'.[8] Clare Gittings has given a brilliantly vivid account of Elizabethan and Jacobean heraldic funerals in *Death, Burial and the Individual in Early Modern England* and, from the material she has collected, at every stage visual signs clearly played a central role in the imposition of that order which was seen as of such vital importance in the organization of the event.

The heralds wore long mourning robes, over which they displayed elaborate embroidered tabards as symbols of their authority. The garment worn by John Anstis the elder (1664–1744), Garter King of Arms, dates from a period when the heraldic funeral was nearing extinction, yet it was traditional in its design (illus. 48).[9] The subject of the embroidery is the royal arms, an example of the way heraldry uses visual signs to wield authority in the absence of the source of that authority, the prince. Sets of late Tudor heraldic instructions show that the very presence of these arms borne in this way at a funeral was not only a sign of the authority of the prince but of royal approval for the virtuous qualities of the person being buried: 'that it may be known unto all that the defunct died honourably'.[10] The heralds marshalled the large and involved processions which noble funerals demanded with wooden batons tipped with brass.

The complex materials produced for the funerals of the great and the good were only of temporary use, but they were no less elaborate and costly for that. Vast amounts of textiles and wooden and metal objects were needed to mark such obsequies, though the time available for the production of the necessary artefacts was limited. The situation was one designers often faced when their work was concerned with rites of passage, whether spectacular triumphal entries had to be prepared, places decked out for weddings or the pomp of funerals devised.

In post-Reformation England black cloth was a standard feature in the heraldic funeral. It was used extensively at home for the laying-in and in

churches for the funeral service itself. Different amounts and qualities of cloth were permitted, depending on the exact rank of the deceased: if the cloth was too fine, hung too low or too thickly, rules of degree could be broken. The cloth also made a striking backdrop for the brightly coloured heraldic shields, mantlings and supporters which were habitually set up against it. Very few of these objects have survived, but many churches still contain canvas or wood hatchments made to hang on the house and then in church over the place of burial. Written sources also mention countless smaller paper pennants or flags which also displayed the family arms and which were set on every available surface, including the hearse.

A hearse was not a means of transporting the coffin, in the way it is today, but a temporary structure set around the coffin to display heraldry, candles, black drapes and, perhaps, inscriptions. They were made of wood or metal and, again, the design of their decorations varied according to the rank of the deceased.[11] Their form was taken as a model for the sets of iron grilles or railings erected around substantial funeral monuments. Closely related was the bier, used for transporting the corpse. An interesting parish bier from Norfolk (illus. 43) was donated to the parish by their priest, Henry Kidson, in 1611 and decorated with improving Latin inscriptions: '. . . the trump shall blow and the dead shall rise . . .'. When a deceased landowner had to be carried down to his country seat the corpse was borne, sometimes across the length or breadth of the country, by a horse-drawn carriage draped in black.

43. Covered Bier, painted wood, 1611. South Wootton, Norfolk.

XI · HERALDIC DISPLAYS

The splendid spectacle of a great magnate being carried to the grave has always had great power. The funerals of Nelson and Wellington in the nineteenth century and of Churchill and Kennedy in our own day gripped the popular imagination. In post-Reformation England the accounts of such spectacles were told and retold by word of mouth and as published records. A substantial number of engravings of royal funerals set the scene using captions and a key to communicate the huge scale of such events. These seem to have been produced in broadsheet format or included in newspapers as rapidly as possible, in order to cash in on the topicality of the subject-matter. An example entitled *Great Britain's Lamentations: Or, the funeral obsequies of . . . Mary . . . Queen . . . 5 March 1694/5*, printed for J. Whitlock near Stationer's Hall in the City of London, sold for two pence a copy, with a view of the procession supplemented by verses set out below in four columns. This was produced as a rival to Allard's famous view engraved by Scherm (illus. 44). In general, the publishers of this kind of popular image sought to stress their accuracy: *The exact Representation of the solemn . . . funeral . . . of . . . John, Duke of Marlborough* appeared in 1722.[1]

In one of the most ambitious publishing enterprises of the Elizabethan era, the Dutchman Johann Theodor de Bry engraved no fewer than thirty-four scenes of the funeral procession of Sir Philip Sidney, which took place on 16 February 1587 (illus. 45, 46).[2] These plates repeat a simple formula. They were printed on a continuous roll over 7 inches wide and 38 feet long and an example was still in working order when John Aubrey saw it many years later.[3] It was intended to be displayed almost as a moving image which 'made the figures march all in order'. The author of the series was Thomas Lant, Portcullis Pursuivant, who supplied a prose account of the event, entitled *Sequitur celebritas et pompa funeris*. The procession is shown moving from right to left along a road, and above the figures there are Latin captions with English translations. The emphasis is on the ritual and the costumes of the 700 or so participants. Each plate shows about a dozen standing figures – occasionally a horse is also included – richly dressed, with considerable attention paid to accuracy of detail and with a good deal of animated gesture. For example, in one scene Thomas Shotboult, Sidney's Lieutenant of Foot, turns to signal to the pair of

44. Lorenz Scherm after Carel Allard, *The Funeral Procession of Mary II*,
engraving, 1695.

corporals following him; behind the corporals, four trumpeters, mouth-
pieces turned downwards, converse with mournful faces. On another sheet
two drummers turning to the viewer appear under a caption which describes
how they are 'playing softly'. There is no attempt to show the crowd of
onlookers or the streets of London through which the cortège passed just
four months after the young courtier's death.

This spectacular ceremony was intended to grip the popular imagination
and sustain the great hero's social memory, despite the maiming of his
natural body in military action in Flanders. There has been, however, a
good deal of speculation that the ceremony was intended either to distract
the London crowd from the execution of Mary, Queen of Scots, which
had taken place a few days earlier or, perhaps, to intensify the nationalistic,
anti-Catholic fervour which that event had triggered.[4] The elaborate and
lengthy ritual of Sidney's funeral reputedly bankrupted its patron, his
father-in-law Sir Francis Walsingham, but cushioned contemporary
society from the loss of an individual symbolic of the health and, some

have claimed, the very identity of the state. It is hard not to agree with those who point out that Walsingham was the main agent in opposition to Mary Stuart and that the timing of Sidney's funeral is likely to have been manipulated in order to increase pressure on the opponents of Elizabeth's foreign policy. Elizabeth herself may not have held acts of reckless military bravery in high regard, but she did accept the propaganda value of the cult of chivalry – with herself as Gloriana, the Virgin Queen – to which Sidney was so central.[5] For some years after Sidney's death his horse was presented to her at the start of the annual Accession Day tilt, in an act of official mourning and an extension of the death ritual.

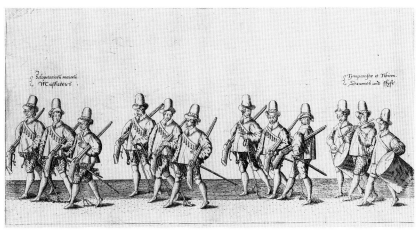

45, 46. Johann Theodor de Bry, engraved illustrations from Thomas Lant's
Funeral of Philip Sidney, 1587.

Sidney's funeral helped resist the inevitable but always abrupt and painful demise of the natural body by re-presenting the social body in an unfolding tableau of chivalry. Such was its success and so powerful were the images produced by de Bry that a permanent monumental body in the form of a sculpted tomb was never erected.

It was, however, not only heroes whose obsequies stressed their chivalric qualities. Armorial displays accompanied many funerals and were used on the permanent memorial once it was set up. The helm and the gauntlets and sometimes even banners and whole suits of ceremonial armour were hung above the funeral monument (illus. 47). This temporary funeral armour was sometimes made of wood, but it could also be made in metal, although probably never of substantial defensive quality. The effigy from the Wyseman monument (illus. 51) was originally placed beneath a set of such funerary armour.

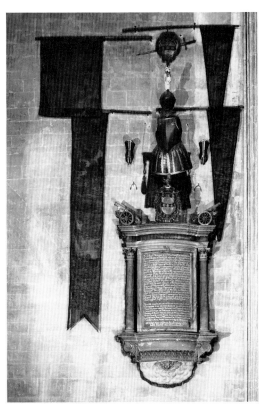

47. Funerary Achievement and Monument of Sir William Penn, 1670.
St Mary Redcliffe, Bristol.

48. Tabard of John Anstis the elder,
velvet embroidered in silks and metal thread,
early 18th century.

49. Funeral Pall, late 15th-century Italian velvet and early 16th-century English embroidery.

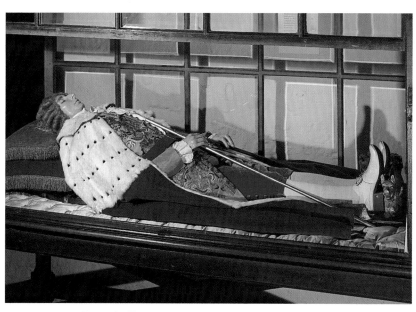

50. Funeral Effigy of Edmund Sheffield, Duke of Buckingham,
wood, leather, wax and textiles, 1735.

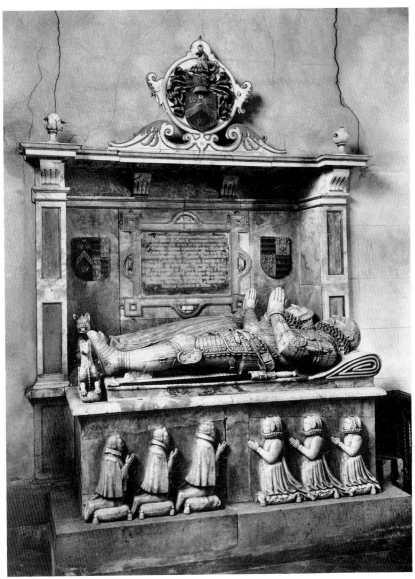

51. Monument to Raphe and Elizabeth Wyseman, alabaster and imported 'marbles', after 1594. St Mary and All Saints, Rivenhall, Essex.

52. Randle Holme, Page from a mid-17th-century sketchbook;
engraving (*left*) and pen and ink and bodycolour (*right*).

Heraldry was not only essential to the grand, public funeral, it was also central in many kinds of monumental design. Indeed, some monuments were little more than a carved stone frame for heraldry, and in many cases the display of achievements and coats-of-arms dominated the composition. The heralds not only designed and authorized coats-of-arms, passing the information on to the tomb-makers,[6] but some of them also practised as commemorative painters and supplied patrons with painted panels. The *Judd Marriage* (see illus. 2) and the *Unton Memorial* picture (see illus. 28) originate from such a source. Sir William Segar, antiquary, herald, poet and painter, is perhaps the best known of a group of artists whose history has yet to be written.[7] Probably the best documented of the herald-painters is the extraordinary Holme dynasty from Chester.[8] There were four generations of Randle Holme, who supplied the Marches of North Wales with memorial paintings throughout the seventeenth century as well as performing other heraldic duties. Their notebooks (now among the Harleian manuscripts in the British Library) are a fascinating *mélange* of jottings, ephemera and business and literary records (illus. 52). After a funeral the church was adorned with hatchments (painted boards of heraldic devices) set up over the family aisle or chapel. Special objects were sometimes made to be carried on or before the coffins of the higher clergy, for example, the remarkable wooden staff and mitre of Bishop Fell at Christ Church, Oxford.

XII · FUNEREAL PARAPHERNALIA

The nobility were not the only social class in whose last rites visual culture played an important role. Associations and fellowships of the lower orders often participated in the funerals of their comrades, fellows and brothers and loaned equipment for the purpose. Relatives without such support would simply apply to the churchwarden to hire out what was necessary or what they could afford (illus. 53).[1] The City of London livery companies had splendid embroidered palls showing their arms and traditional symbols – the shovel, hour-glass and skeleton (illus. 49). These could be flung over hearse frames, themselves often decorated with moralizing texts. The iconography of these palls and hearses demonstrated the combination of the secular and the religious which characterizes the fully developed Protestant death ritual. The pre-Reformation examples show traditional iconography concentrating on themes of redemption or, perhaps, the symbolism of the relevant patron saint. In some cases, the narrative scenes were set on panels which would hang against the sides of the coffin rather than rest on the top. In this way they could be seen when the coffin was borne on the shoulders of bearers, or on a bier or carriage. The Saddlers' Company pall has a red velvet top, decorated with a woven pattern of gold thread; on its sides are the company arms, the symbols of

53. Attributed to Paul Sandby, *A Funeral Procession*, pencil and wash.

Christ's name and Latin inscriptions. The Fishmongers have a mermaid on their pall and an extraordinary nautical version of St George, together with Christ giving the Keys to St Peter. The Brewers have their staple, barley, as well as the Virgin of the Mandorla. The mature post-Reformation design tended to reject such iconography. Images of Christ, the Saints or the Virgin would have been regarded on the streets as provocative and a threat to public order. Instead, secular themes were favoured which concentrated on social cohesion and continuity.[2]

Other pictorial and printed ephemera were produced to meet the sacramental needs which are so often a part of more modest funerals and the customs that accompany them. Food was habitually consumed, partly as hospitality but also to act as a focus for ideas about the redemption of sin: the refusal of a dole would have been grossly disrespectful to the deceased and to the bereaved. Since the Reformation, wakes have offered superb opportunities for such gifted observers of social mores as Hogarth (the final scene of the *Harlot's Progress*, for example) or Dickens. In seventeenth-century Herefordshire a 'sin-eater' consumed the sins of the deceased by eating a loaf of bread and drinking a bowl of ale over the corpse as it journeyed to the grave; for this he was paid six pence by the bereaved.[3] As with the doctrine of Purgatory, this custom demonstrates an attempt to cope with the suddenness of death and the post-Reformation anxiety that the living were unable to relieve the dead of their burden of sin. Illustration 54 shows an example of the wrappers around the biscuits which were introduced in the later eighteenth century to be eaten at a funeral. The biscuits were sealed with black wax and wrapped in simple printed labels bordered with a heavy black line. Such labels would have been privately printed for the funerals of the well-to-do, in this instance by the local surgeon. The verse printed on the label is a standard example of the *memento mori* type.

From the later seventeenth century the heralds were challenged by the men who have come to be called undertakers, that is, tradesmen with skills associated with funerals who became involved in the whole 'undertaking'. And it is clear from advertisements and trade-cards that the undertakers supplied a wide range of artefacts:

Richard Chandler / Armes-Painter and Undertaker / at St Lukes Head in Hill Lane in / Shrewsbury / completely furnishes Funeralls / with Coffin burying suit, pall hangings, Silver'd / Sconces & Candlesticks, Cloakes, Hatbands, Scarves, Favors / Funerall Escocheons, Coaches, Herse Wax Lights flambeaux links / Torches, Ticketts etc and performed after ye same manner / as by ye Undertakers at London at Reasonable Rates.[4]

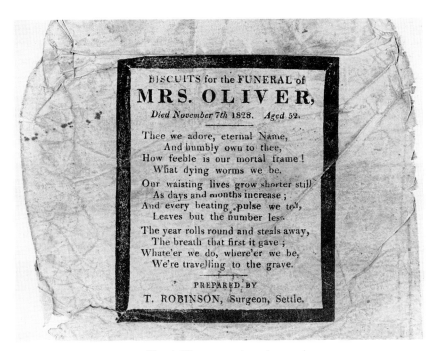

54. Biscuit Wrapper, early 19th century.

This new trade generated a good deal of printed ephemera (illus. 55–7), much of it mixing religious and secular iconography as well as illustrating the ritual actually taking place (illus. 55). Printed funeral invitations are known from at least the later seventeenth century. The great advantage of the advanced technology which allowed such tickets to be printed was that a relatively sophisticated but non-specific design could thereby be simply and quickly adapted for a particular occasion. Stock items simply showed a combination of standard motifs, such as a cortège, a weeping putto, skulls and crossed-bones, Fame or a scythe, set into the border with a blank space for the hand-written message. Slightly fancier versions included similar motifs with a specific inscription overprinted below. Others had some words of the inscription printed with details left blank, to be filled in by the undertaker as required. Pall bearers were granted a number to position them at a particular corner of the pall and they were asked to bring their tickets with them. It was accepted that attending a funeral was partly a preparation for one's own.

The woodcuts among this genre of ephemera use the iconography of the popular *memento mori* tradition. Some exhort the recipient with scriptural phrases such as 'Nothing surer than Death; Nothing so Uncertain as ye

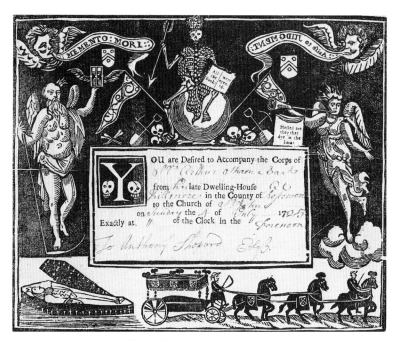

55. Funeral Invitation, woodcut, 1705.

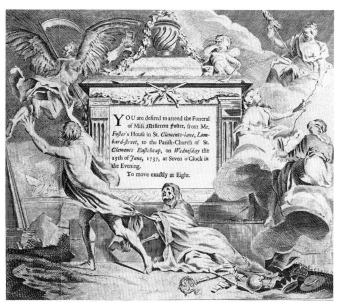

56. Antoine Jongelincx after Noel Coypel, Funeral Invitation,
etching and engraving, 1737.

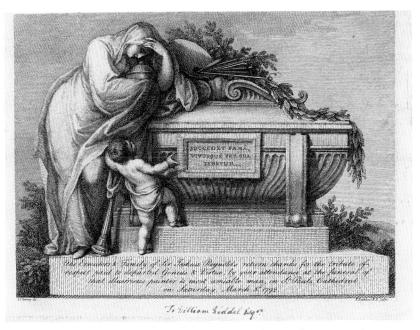

57. Francesco Bartolozzi after Edward Francis Burney, Invitation to the
Funeral of Sir Joshua Reynolds, etching, 1792.

Tyme when' or 'Oh Death where is thy sting' on a ticket of 1781. Both
engraved and woodcut invitations tended to re-use stock narrative or
allegorical compositions, such as the dramatic print derived from a compo-
sition by the French academic painter Noel Coypel (1628–1707), versions
of which are encountered in England as early as the late 1730s. Before
the Act of Parliament (1735) on copyright which followed Hogarth's
petition for one, these designs were easily pirated. For example, a compo-
sition signed 'G. Bickham Sculp' printed on a card filled in during April
1722 was re-used for another relating to a funeral in April 1743 bearing
the signature 'J. Sturt Sculpsit'.

The ticket to the funeral of the portrait painter Sir Joshua Reynolds was
etched by his fellow Royal Academician Bartolozzi; it shows a mournful
figure of Genius, inconsolable at the loss, being comforted by Fame who
points at a classical inscription (illus. 57). Below, in suitably grand phrasing,
is the text of the invitation sent to the recipient as 'thanks for the tribute
of regret paid to the departed Genius & Virtue'.

The professional development of the undertaker is an early indication
of a slow process whereby the death ritual has been separated from
everyday social experience, a practice now accepted as normal.[5] As Ruth

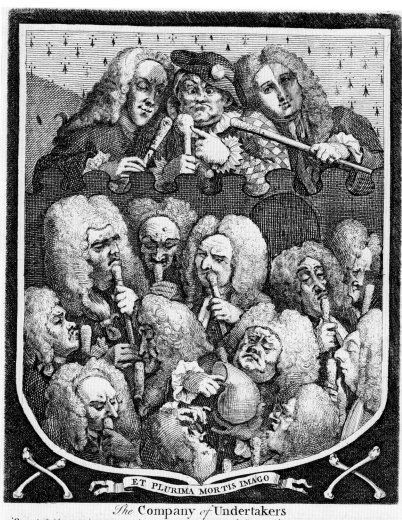

ET PLURIMA MORTIS IMAGO

The Company *of* Undertakers

Beareth Sable, an Urinal *proper, between 12* Quack-Heads *of the Second & 12* Cane Heads *Or,* Consul-tant *. On a* Chief *Nebulæ, Ermine, One Compleat* Doctor *issuant, checkie Sustaining in his Right Hand a Baton of the Second. On his Dexter & Sinister sides two* Demi-Doctors, *issuant of the second, & two* Cane Heads *issuant of the third; She first having One Eye conchant, to-wards the Dexter Side of the Escochoen; the Second* Faced *per pale proper & Gules, Guardent. —*
With this Motto ———— Et Plurima Mortis Imago *.*

58. William Hogarth, *The Company of Undertakers*, etching and engraving, 1736.

Richardson argues, the role of affective behaviour in the rite of passage has slowly been eroded, a process still continuing as undertaking becomes an international industry ever more closely linked with financial services such as life assurance and property mortgaging. In the early modern period the rise of the undertaker and a perception that the death ritual was undergoing a transformation encouraged a genre of black humour about the labour associated with death, which as the gravedigger in Shakespeare's *Hamlet* suggests has long featured in the popular imagination. The impassive face of the sexton was to become a stock literary topos, as was the suspected hypocrisy of the undertakers as illustrated in Hogarth's engraving, *The Company of Undertakers* (illus. 58). Here Hogarth made full use of the historical connection between heraldry and the organization of funerals by choosing a coat-of-arms as his vehicle for satire. Lines of inscription set out below the lampoon on the undertakers' mock-solemn expressions, make play with the technical language of heraldry and the batons traditionally carried by those marshalling funerals.

XIII · LITURGIES

We have already seen (§ IV) how the loss of belief in Purgatory distanced the dead from the living. This contact had traditionally been sustained with the dead through the intercession of priests. Consequently, the Reformation had a dramatic impact on the role of the clergy in the death ritual. The outlawing in 1529 of masses for the dead greatly reduced the income of the clergy as new laws on images forced them to change their apparel. A unique pre-Reformation survival of a requiem chasuble (illus. 59) shows the impression of the rebus and monogram of Robert Thornton, Abbot of Jerveaux, Yorkshire, and the iconography suggests it must have been worn for the celebrations of requiem mass. Its Latin inscriptions make reference to the Final Judgment and among the embroidered angels are half-figures of the dead rising from their graves. Thornton died in 1533, the moment when new laws concerning religious iconography were starting to appear on the statute book.

In general, the Reformation tended to reduce the importance given to the clergy's role in religious experience.[1] Luther taught that the laity

59. Chasuble for Requiem Mass, velvet embroidered in silks and metal thread.

should properly play a more active role in church services. Much of Protestant devotional literature which prepared people for death intended for domestic use without any professional religious instruction. The role of the word spoken from the pulpit was, however, also given greater significance and the funeral sermon became an important sub-genre in a body of widely published literature. Again the intention here was to emphasize the didactic potential of the funeral sermon as part of *memoria* and to reduce the importance of the mass. This tendency is illustrated in the original sources time and again. For example, in 1620 Elizabeth Juxon made a death-bed request that her funeral sermon should be on a text from Job (7, 3–4) on the nature of vanity. Stephen Denison, Vicar of Kree in the City of London, duly spoke of the way in which her death was made easier with due preparation; his rhetoric is full of the imagery of the *memento mori*: 'Therefore in bed, put the[e] daily in mind of thy grave . . .'.[2]

The most important themes throughout the ritual taught that death was an experience from which the bereaved could learn and the blessed gain a glimpse of the joys of regeneration. That death was a return to life was an idea influencing the designers of objects as much as it did the clergy preparing their sermons. The small handbell in the V&A (illus. 60), with its inscription 'memento more [*sic*]', and another, cast in 1608 for St Andrew's, Yetminster, Dorset, inscribed 'I sound to bid the sick repent / In hope of life when death is spent', are solid metal versions of a theme pursued by a dozen poets: 'The beating of thy pulse (when thou art well) / Is just the tolling of thy Passing Bell'.[3]

60. Sexton's Handbell, bell-metal, 1638.

61. Thomas Stothard, *Burying the Dead*, watercolour, *c.* 1792.

Complex funeral music created particular effects through its use of subtle harmonies and characteristic tone colours; here too the Reformation had a profound effect on the ritual. The Anglican church stressed the need for clarity in the settings of devotional texts so that ornamentation should not obscure the discourse, whether spoken or sung. Calvin was hostile to effects which risked making the hearer 'effeminate with disordered pleasures'.[4] Such guidance encouraged Protestant composers to make use of subtle chromaticism rather than complex polyphony. It took some time, however, for the funeral setting to receive proper attention. As late as 1724 William Croft was able to comment in a preface to his setting of the burial service that there was 'scarce any thing of that kind in . . . any Cathedrall in England: for want whereof great confusion and perplexity in that kind of performance generally ensues, to the great detriment and disadvantage of these solemn rites'.

Music was so much a part of funeral rituals that a few observations on it are in place. The funeral of a soldier like Sir Philip Sidney, or of state personages, proceeded to a muted military accompaniment much commented upon by poets.[5] Francis Barlow's illustrations to Francis Sandford's account of the funeral of George, Duke of Albemarle, in 1670 note that the drums were completely and tightly covered with black baise or 'cypress', not only for their colour but to gain a muted effect. De Bry's illustration of Sidney's funeral notes that the music was played very quietly. A fife was played in accompaniment with these drums, but the bright tones of the brass trumpets were silent. An altogether more ambitious project came later when Henry Purcell adapted for the funeral of Mary II a piece originally written as stage music about a year before. The Queen had died of smallpox on 28 December 1694 and was buried at Westminster Abbey the following 5 March. Four 'flat mournfull Trumpets' playing a slow march led the procession to the Abbey. The effect was dramatic: 'I appeal to all that were present . . . whither they ever heard any thing so rapturously fine & solemn & so Heavenly in the operation, which drew tears from all', noted a contemporary who heard the performance.[6] As it still does, Purcell's music prompted in its original audience an emotional response, something additionally memorable about the event. As the mourners moved away from the graveside, however, and the natural body of the Queen was left to decay, the death ritual was by no means over.

XIV · WORN OUT AND IN

A pen and wash drawing by Thomas Rowlandson shows a small group of women and children around an open coffin (illus. 62). Rowlandson, here responding to one of the traditional preoccupations of the history painter, was interested in the range of expressions and the dramatic intensity of the eyes of his subjects as they gaze upon the corpse. The deceased is seen nearly in profile, with the suggestion of a shroud already in place; it cannot stare in return for, according to ancient convention, its eyes have been closed. Nearest the viewer a figure, perhaps the widow, seems resigned to melancholy while opposite her an older woman, perhaps her mother, weeps into a handkerchief. Two children show contrasting expressions of a near-hysterical disbelief and incomprehension. This range of reactions in the face of domestic tragedy was extremely attractive to eighteenth-century painters, for example the Frenchman Jean-Baptiste

62. Thomas Rowlandson, *Mourning Figures around a Coffin*, pen and ink and wash.

[84]

63. Thomas Stothard, *Studies of Figures For a Mourning Scene*, pen and ink, c. 1800.

Greuze. A group of drawings from around 1800, this time by Thomas Stothard, seems to show preliminary ideas for a more formal historical scene (illus. 63); around the suggestion of a death-bed are grouped mourners in various poses: wringing their hands, praying and comforting one another.

The visual culture of mourning amounted, however, to a good deal more than simply that of artists choosing scenes of sorrow as their subject-matter. Stothard's attendant figures at the bedside have already started mourning, a stage in the death ritual which inspired the design of a whole range of artefacts. This visual culture was aimed at the bereaved – the living – and had little to do with the fate of the deceased. In order to ease the psychological burden of bereavement mourning allowed, then as now, the individual time in which to spread the potentially damaging effects of the loss, the sudden, awful absence. It was not, in the early modern period, so constrained by widely accepted rules as in the nineteenth century; but it did generate a whole host of artefacts to be worn, distributed or left around the house, many of them designed to release a palliative emotional response. Mourning took place both inside and outside the home and therefore the design of mourning artefacts depended partly on whether their function was private or public. These polarities defined a cultural structure which had a dramatic effect on the politics of sex and gender.

In general, mourning dress among the richer classes was circumscribed by the rules that applied to all the clothes of such people: the laws of sumptuary that we have already seen applied to funerals.[1] The medieval practice was to ensure that one's precise social class was identifiable by one's dress; such rules were protected by statute. The length of a mourning train was a token of rank – the longer the train the higher the rank, and

pretenders to length and hence rank were duly punished. This aspect of the ritual was precisely concerned with social differentiation. In grand Elizabethan funeral processions important male mourners wore gowns with hoods. Only the upper ranks were allowed to cover their hair at the funerals of the great; lesser participants had respectfully to wear their hoods over their shoulders.[2] Gradually these hoods became more decorative, growing into the long scarves or sashes still in use as late as the nineteenth century. Even mourning jewellery given away as a gift was carefully selected with an eye to the recipient's rank and the closeness of the relationship. In his will Samuel Pepys made arrangements for the distribution of 128 rings, at a total cost of over £100 and falling into three price bands (illus. 64).[3]

In some places in England spoons were distributed, although not as frequently as rings were.[4] Only a few examples are known and pairs of such spoons are rarer still. One silver spoon in the V&A (see illus. 13) is engraved with the familiar iconography of the *memento mori* – a skull and the words 'Live To Die, Die To Live' – together with the coat-of-arms of the Strickland family of Boynton in Yorkshire. The maker's mark

64. Mourning Rings: (*from left to right*) 1788; 1790; *c.* 1795; late 16th century; 1764; mid-17th century; Gold, some enamelled and set with miniatures, human hair and precious and semi-precious stones.

65. The Tor Abbey Jewel, gold and enamel, *c.* 1546.

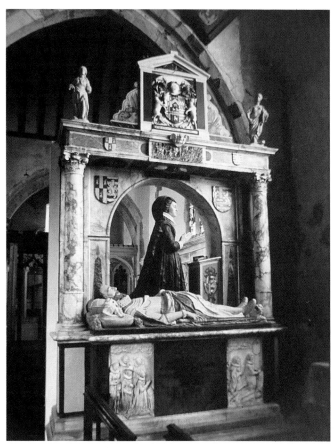

66. Epiphanius Evesham, Monument to the 2nd Lord Teynham, alabaster and imported 'marbles', after 1622. St Peter and St Paul, Lynsted, Kent.

67. Handwarmer with moralizing inscription, Lambeth delftware, 1672.

identifies it as the work of Thomas Mangy of York and it is hallmarked for the years 1670–71. It is one of a group of similar spoons by Mangy based on a Scottish disc-end type of design.[5]

New fashions were extremely rare in sixteenth-century mourning dress. Modesty and decorum, not novelty, were emphasized, but those small innovations which were permitted, those which might produce new contours, tucks or folds, were immediately subsumed within the system of rank. Once long tippets and hoods were no longer fashionable, new conventions were established on the hierarchy of various stuffs used to make hat-bands: silk was more exalted than crêpe, which was higher than satin. The adjustments in fashion demanded by mourning costume affected women and men in different ways. Women had modesty imposed on them, indeed a 'modesty' was the name given the white veils covering stylish *décollétages* in the seventeenth century. The covering of women's hair, enjoined at all times, was obligatory in deepest mourning, but neither of these rules were applied so vigorously to men.

Colour, other than black, white or their close neighbours, was never encouraged in the early stages of mourning. 'Cypress' was, as we have seen, worn by Lord Albemarle's funeral drummer and by Lady Unton, and its colour was synonymous with the richest black: 'Cyprus black as e'er was Crow' (*The Winter's Tale*, IV, iv, 221). These references are to a newly fashionable Italian silk, so named *c.* 1600. But white could also be suitable for mourning if the deceased was regarded as an example of virtue. Young virgins of either sex came into this category, as did the painter Angelica Kauffmann, at whose funeral in 1807 all the female mourners wore white.[6] Sometimes black and white were mixed. The famous heraldic manuscript which describes the Elizabethan funeral of Lady Lumley shows that the pairs of almswomen who attended her corpse processed in black gowns with white hoods, which were wired out.[7] The French mourning hood adopted by Mary, Queen of Scots, in 1559 at the death of her husband was in white, as was the linen cap. Men who wore cloaks rather than longer robes also carried dull, black swords in sheaths of the same colour (illus. 68).

In some circumstances other dark colours might be suitable for certain stages of mourning. Red was associated with the doctrine of redemption through its connotations with the blood of Christ; purple and mauve were adopted as appropriate mourning colours for royalty – a kind of mixture of black and red regarded as imperial since Antiquity. Equally, the code of heraldry did not always rule that black was associated with sorrow or mourning.[8]

68. Mourning Sword, hilt of blackened steel, early 18th century.

All mourning apparel had to avoid having any kind of shine or reflective surface, given the continuing belief in the ancient myth, which features, for example, in the story of Narcissus, that the soul is vulnerable in a reflected image. All domestic images – and images were regarded as potentially dangerous at a time of death – in deepest mourning portraits and mirrors were turned to the wall and even jewellery had to effect a dull surface – hence the nineteenth-century pleasure in the discovery of the mineral jet. Before this pearls had long been valued as suitable for mourning; being pure white they signified virtue and being dull of surface they suggested modesty. Where pearls were unavailable or too expensive, sets of black beads were an acceptable substitute.

Mourning was officially divided into phases: an intense period was followed by an intermediate phase, or phases, before normal behaviour could be resumed. Attempts were made to organize mourning in such a way as to preserve social differentiation. The most complex ritual was, predictably, at Court, where new sets of apparel were required for each state of mourning. As one might expect, other branches of the establishment adopted mourning dress at the death of a monarch. The legal profession, especially those practising advocacy in the courts, was (and remains) a case in point: the gown worn by junior barristers may well be a version of the mourning gown introduced at the death of Charles II in

1685.[9] Gowns worn previously were more elaborate, for at the Restoration of the monarchy in 1660 they acquired various decorative devices over the cloth, such as velvet facings, lace and tufts. Having been replaced by something rather more modest during the period of mourning for Charles II, the expense of such elaboration was rejected by the profession and the simpler mourning gowns were retained for normal use. This revolution met with some opposition and the new costume was described as a 'scandalous Livery which resembles those that Bearers usually wear at Funerals'.[10]

To the establishment's disgust, the eighteenth century saw the extension of public mourning for a monarch to broader social ranks. Lou Taylor quotes from a society journal of 1731, complaining how 'Tradesmen's wives' were spotted in mourning dress as if they were attending the Court of St James's. Such complaints were, however, ineffectual and by the end of the eighteenth century the middle class seems to have adopted modes of mourning previously restricted to the aristocracy. This was not only a consequence of pressure on social mores, but also a reflection of changing patterns of trade and new technology. By the late seventeenth century Huguenot weavers were producing, in significant amounts, a new kind of silk which came to be known as mourning crêpe. This started to undermine the importation of expensive foreign stuffs, a cost previously only met among the aristocracy.

The Barbara Johnson dress album (illus. 69) illustrates how the material culture of the death ritual bears witness to the application of standard rules to a wide range of social ranks; it records the fabrics worn by middle-class women in the later eighteenth century.[11] The spaces in the album left unfilled by fabrics, their prices and dates contain fashion plates and cuttings from society magazines about the country seats of the gentry. This evocative mixture of money, property, land, architecture and fashion is still familiar to us from the pages of certain pricey monthly magazines. Johnson's own mourning costume seems often to have been in grey stuff, although she clearly felt that black was appropriate for the deepest mourning, for example for her parents. A few months after her mother's death in February 1759, however, she was in a 'grey tabby gown'; by December she was wearing scarlet.

All these rules about costume were set within the principal structural framework of mourning, which made an important distinction between public and domestic practices. The demarcation here was not simple: private and public were not synonymous, for example with indoors and outdoors; mourning behaviour was sometimes the same in public and in

A Gentleman and Lady in the Undress of the Year 1771.

a Garnet Damask Gown
eleven shillings a yard.
eleven yards.

January 1771.

a black Italian Lutestring
negligee. eighteen yards.
three qrs wide. seven shillings
a yard:

Northampton May 1771

mourning for my
Uncle Johnson.

A Gentleman and Lady in the Court Dress of the Year 1771.

a purple and white copper-plate
linnen Gown. seven yards
3 - 2 a yard.

Northampton May 1771

69. Page from the Album of Barbara Johnson, with sample of black lutestring labelled 'May 1771. Mourning for my Uncle Johnson'.

private spaces. Artefacts have survived which were designed for cultural practices in both domains. Today very little attention is paid to the visual culture of mourning, and extended private grief is by and large discouraged as psychologically unhealthy.

Public mourning was almost totally concerned with signifying practice rather than with psychological therapy. By this stage in the death ritual the natural body was virtually forgotten and culture's concern was to support the accumulation of meanings attributed to the social body. Primarily, the rank of the deceased was respected by the rules of mourning. For a noble, however, no honour was attached to mourning by one's social inferiors: the peer group was expected to attend, to support and maintain the sense of difference. For formal occasions, for example sitting for a portrait, well-to-do widows would still wear black many years after their bereavement and, what is more, clothes would be cut in unfashionable styles. The moralists taught that mourning was incompatible with vanity.

For the historian of visual culture, half-mourning is a particularly interesting state because it seems often to have demanded the adaptation of kinds of costume habitually worn in public, rather than the replacement of all conventional modes of dress by garments of a type specific to deepest, mainly private mourning. One pair of leather gloves in the Bath Costume Museum (illus. 70) is perhaps an example of this phenomenon. Historical gloves are notorious among costume historians for their unwillingness to disclose secure data. These gloves appear, however, to have been of a kind fashionable in early seventeenth-century England, perhaps imported from the Continent and possibly used as a lady's riding gauntlets. The only explanation for the additional frill of black is that they were worn during half-mourning. In the following century half-mourning fans were made with white leaves mounted on black sticks.[12]

70. Woman's Riding Gauntlets, leather with embroidered satin cuffs, late 17th century.

XV · OBJECTS OF MOURNING

Heraldic funerals have demonstrated how the death ritual produces objects which reinforce the image of the social body. During the eighteenth century artefacts were produced to accompany state or public mournings, a commemorative industry perhaps started in response to Jacobite memories of the expelled Stuart kings, and especially the martyr Charles I. After 1751 fashionable ladies could carry an ivory and paper fan which helped set the tragic death of Prince Frederick in the context of a pantheon of British princes of Wales, all prematurely departed (illus. 71): in the centre of this fan is an historical cenotaph with a sequence of portrait roundels of princes which runs from Edward (*d.* 1376) to Henry (*d.* 1612). Alongside an inconsolable figure of Britannia sits Time with his scythe, and with an hour-glass somewhat eccentrically set on his head. To complete the sequence Time carries a portrait of Frederick who, on the far right, is

71. Mourning Fan for Frederick, Prince of Wales, hand-coloured etching and engraving with ivory sticks, 1751.

crowned by an angel carrying the banner of St George and assisted both by St George and by Fame, who trumpets overhead. Far to the left there is the pathetic figure of Frederick's widow, who can only gaze at his image, while a lady-in-waiting attempts to distract her with a devotional text. Fans are recorded as mourning accessories as early as 1721 and, like any other item of apparel, they could be adapted for mourning, either by using a standard design in colours such as grey or dark green or by including new and suitable subjects.

During the eighteenth century other heroes joined the Royal Family as subjects for national mourning, a trend which was to reach its peak under the Victorians.[1] An interesting development of this kind was the spate of commemorative art encouraged in the United States after 1800, following the arrival of a mass of English works – pictures, handkerchiefs, ceramics and so on – produced to mark the death of George Washington in the preceding year.[2] In England, the death of Nelson in 1805 engendered a vast range of objects: a mug with a sailor and a marine mourning over his tomb; silk and glass pictures depicting Britannia distraught or the famous funeral carriage; prints showing the funeral flotilla on the Thames; brooches, ceramic plates, badges, lockets and memorial rings. In addition, there was an ambitious scheme for building monuments across the country, and discussions were initiated into the establishment of a permanent national mausoleum for the nation's heroes.[3]

72, 73. Memorial Slide for Elias Ashmole, gold set with crystal over knotted hair.

Jewellery had, of course, long been made for private mourning purposes and, as with costume and other artefacts, it was intended to help extend the process of death and display the process of death in the ritual, excepting the minute amounts of hair that find their way into mourning lockets and some specially adapted rings (illus. 72, 73).[4] Tiny strands of hair could be mounted on finger-rings, either in a hollow hoop inscribed with the name and date, or set in the bezel against a ground of corded silk. Such rings were made in quite large numbers for distribution among friends and other mourners and this practice survived into the nineteenth century.

They fall into standard types, all within the *memento mori* tradition: an enamelled skull with diamonds for eyes, a hardstone carved as the skull and crossbones, short engraved inscriptions which identify the deceased (from the mid-seventeenth century); perhaps a small figurative reference to the cause of death or some other personal detail.[5]

A finger-ring in Bristol is inscribed 'C. B. Templar / periit Jan'y 6 1786', and its octagonal front shows a shipwreck under glass. Around 1800 the iconographic pattern of such rings was firmly set and fell into two types: the female figure in Antique dress draped over a sarcophagus, or cypress trees. Similar iconographic combinations were employed in mourning slides and other personal jewellery, a tradition deriving from the late-medieval habit of including in the *memento mori* skulls and skeletons on rings. Entwined marriage rings from the seventeenth century sometimes showed hands poised over skeletons, an idea very close to that expressed in the *Judd Marriage* painting (see illus. 2).

The most dramatic early example of *memento mori* jewellery is probably the ornament found at Tor Abbey in Devon (see illus. 65). This takes the form of an enamelled gold coffin presumably designed to be hung on a gold neck-chain. Its lid can be detached to reveal a skeleton and carries the inscription 'THROUGH THE RESURRECTION OF CHRISTE WE BE ALL SANCTIFIED'. Its *moresque* lid decoration suggests a date after *c.* 1546. Almost any objects of personal apparel could be decorated with *memento mori* iconography: in the seventeenth century silver death's-head watches were made, and examples exist in several British public collections.

Pictures could also function to sustain the memory of the deceased. Some pictures were small enough to carry on the person (in a bag or pocket); others were intended for intimate, domestic contemplation. The Dulwich College Picture Gallery has a portrait by John Greenhill (*c.* 1640/45–1676) of *Mrs Jane Cartwright*, recorded in the inventory of her husband William as 'my Last wifes pictur with a blacke vaile on her head' (illus. 74). This must be a reference to Jane Hodgson, whom he married in 1654 but who apparently died before him.[6] The painting, showing his wife in mourning clothes, is a reference not so much to her emotional state but to his. A more conventional portrait in the same collection, *Lady Jones* (dated 1682), shows her in mourning for her husband, a prominent judge; it is the pendant to a portrait of *Sir William Jones* by the same artist, Simon Du Bois (1632–1708).

In fashionable centres such as Bath around 1800, ivory pictures were produced, many of them of memorial subjects. Ivory was a particularly suitable material for this purpose. The richness of its colour and texture

74. John Greenhill, *Mrs Jane Cartwright*, oil on canvas, before 1676.

75. Ivory Picture, 1800.

made a striking combination with black backgrounds. One example (illus. 75) has preserved its boxwood frame and labels which identify the makers as 'G. Stephany & J. Dresch, Sculptors in Ivory', a business known to have been operating in Harington Place, Bath, in 1800. The picture, inscribed 'In affectionate remembrance of Henry Gibbs and Grace his wife', shows a mournful female figure standing beneath a weeping willow and leaning over a pedestal and urn. This modest, domestic image is fitted with metal tabs and a hook for hanging on a wall. The iconography of such mourning pictures was determined by a mixture of traditional symbolism and fashionable style. The willow was a tree which not only suggested sorrow through the evocative pitch of its falling branches – which were thought to resemble the widow's 'weeds' – but was also taken as a symbol of the Resurrection through its capacity to produce masses of new growth every year.[7] Evergreens also symbolized the everlasting life of the believer and the victory over sin. Rosemary never lost its leaves and its powerful aroma must have been a godsend at lyings-in. Thistles, perhaps present in the Crown of Thorns, were symbolic of the sorrow and sinfulness of earthly existence. Columbine (from the Latin *columba*, the dove) suggested the Holy Ghost.

The mourning figure in the Bristol ivory picture appears in endless variants in Neoclassical art and decoration. Robert Adam and John Flaxman are just two among a large number of artists who employed the motif extensively in two-dimensional and modelled versions in decorative schemes. The urn itself also became a popular motif. It was regarded as part of the conventional furniture of the grave through its associations with the burials of the ashes of the dead in Antiquity, and the medieval practice of burying the organs of the deceased in one place and the remainder of the corpse in a coffin elsewhere.[8] In the mid-1770s Josiah Wedgwood started producing ornamental urns in the form of copies of Greek vases, some of which appear to have been used as memorial vessels.[9]

In church, as their souls were comforted by the lengthy sermons which were such an important part of the developing Anglican liturgy of the period, the hands and laps of the congregation could be warmed by small delftware handwarmers. The example shown here (illus. 67) was made in Lambeth in the shape of a book and has inscriptions of the *memento mori* kind: 'To potter's clay thou takest me to be/Remember then thy own mortality. 1672'.[10] If we return to the analogy with the meanings acquired by language, we find that what is sustained in all these visual signs operating in all these public, semi-public and truly private spaces is, of course, the memory of the deceased: the signifier of the body at death losing ever more contact with its signified, the by now corrupting natural body.

76. William Stanton, Monument to the 1st Earl of Coventry, marbles, soon after 1699.
St Mary, Elmley Castle, Hereford and Worcester.

XVI · THE MONUMENTAL BODY

In the aftermath of death, sorrow could suddenly well up. The purpose of the fifth stage of the post-Reformation death ritual was the achievement of something more permanent than tears and fleeting reminiscences. As the natural body decayed, the ritualized monumental body prevented the social body from being overwhelmed by a similar fate. The monumental body was to be set up at the place of burial to mark its site and was designed to stand for ever as a replacement for the social body. As a subsidiary function, it also acted as a reminder of the living form of the natural body.

In the church at Elmley Castle, Hereford and Worcester, stands William Stanton's splendid monument in commemoration of the 1st Earl of Coventry (illus. 76). This location was chosen by the patron, Coventry's second wife and widow, after the monument was turned away from Croome d'Abitot, Warwickshire, the family seat, by her stepson, the 2nd Earl of Coventry. He acted on the grounds that the claims regarding her pedigree made in the monumental inscription were wrong, and that the monument was therefore an improper memorial to his father.[1] The matter ended at the Court of Chivalry, where an action was heard against the herald employed by the Dowager Countess. The final, legal judgment has been lost but the monument has survived, with its inscriptions referring prominently to the 1st Earl's second wife.

Commemorative art both describes the past life of the deceased and establishes the person's future reputation. The place an individual occupies in the collective memory and in the private thoughts of a relative is partly shaped by the image set by the monumental body. Art history has been slow to take these functions seriously. Funeral monuments are a form for which the traditional conceptual vocabulary of the discipline proves barely adequate.[2] The terms of art history, such as naturalism and idealism, are hard to apply to sculpted effigies. There can be no doubt, however, that the monumental body represented by tomb sculpture was the product of the artist's imagination. Each image had to be invented afresh even when artists re-used motifs or repeated the cutting of a statue a second or third time. Each combination of forms was a unique solution to a particular commission, responding to the inventiveness of the designer as data, as narrative might respond to an historian's arrangement. For example an

effigy, usually taken to be the central motif in a monument, may present the life of an individual in a particular way; other forms – the architectural framework, the decorations, texts, heraldry and allegorical figures – may together assemble a particular image of the subject's social body. Images of piety, charity, authority and public service appeared on monuments and confirmed a reputation for the subject which had perhaps already been established by the words of the funeral sermon. In the Protestant tradition the very presence of tombs acted as reminders of mortality;[3] Protestant monuments were designed to be read as examples of virtue. In skilful enough hands and given sufficient ambition on the part of the patron, the monumental body could invent for posterity a completely new *persona*.

But such invention did not result from the visitation of Genius. For the making of funeral monuments was an artistic practice in which patrons exercised close controls on the designer and on the sculptors, masons and painters who realized their plans. All substantial monuments were bespoke; as with painted portraiture there was no off-the-peg trade in tombs in post-Reformation England. Much of the surviving documentation makes it clear just how closely the tomb-makers were supervised. Illustration 77 is a design supplied by a late-sixteenth-century artist, and it is heavily anno-tated by the patron. Because of these economic conditions post-Reformation funeral monuments have often been condemned as artistic failures, since they rarely gave priority to the invention of new forms. In this, as in other ways, the form that the monuments took cannot be explained solely through the terms and discourse of art-historical discussions about sculpture. So, what were the specific demands placed on the makers of funeral monuments? What questions does art history tend to ignore to its cost?

As we have seen, the monumental body was an invented form designed to replace, in theory for ever, the life that had been lost or was eventually to be lost. In so doing, the monumental body had to respect certain demands made on the visual culture of the death ritual, specifically those of continuity and differentiation.

Deaths open up spaces in social and personal relations. Anthropologists and sociologists have long argued that the existence of complex patterns woven in the cultural fabric secures a culture from fragmentation and allows constructive social intercourse. On a personal level, the sense of occupying a space in the pattern can be challenged by what social theorists call alienation, that is, an individual's realization that either he or she has no place, or that it is not worth occupying. Cultures are vulnerable to fragmentation and individuals may be alienated by countless events, of which death may be inevitable but no less traumatic for that.

77. Gerard Johnson, Design for a Monument for John Gage and his two wives, 1595.

Commemorative art played a central role in combating fragmentation. At the request of the patron, the painter, sculptor or designer had to invent an image that would help the culture to survive. Religions might resist the effects of death by teaching the eternal life of the soul, but in the cultural terms of the living, the monumental body was in itself a signal of continuity. Monuments could suggest continuity in a variety of ways: by their location, design, material, iconographic programme, inscriptions and the heraldry that was taken so seriously by contemporaries but which we tend to reduce to the status of an antiquarian curiosity.

Another specific ritualized function demanded of funeral monuments was the need for the monumental body to sustain social differentiation. The theory of the Two Bodies held that the demise of the natural body should not necessarily result in the total loss of that other aspect, the social body: 'This King dies [but] a King lives still'. As a sign, the meaning of the body at death is transformed as its signification is established less and less by its natural aspect and more and more by its social aspect. Continuity is preserved as that which is signified becomes less and less dependant upon the signifier. The relations between the two aspects of the sign become increasingly arbitrary and the apparent continuity of the social body, like the authoritative meaning of language, appears as an artificial construction sustained as a figment of the collective imagination.

As with discontinuity, Death's assaults on social differentiation had to be resisted by the ritual. In post-Reformation England, the sense of belonging in society went hand in hand with a recognition of difference, that is, the ideology that all individuals had a place in the pattern of things and that such places had to be maintained to preserve the culture. The sense of difference was reinforced by the clear evidence of the social world which demonstrated that not all individuals filled the same place. Death, however, was described in the teaching as both inevitable and, as we have seen in the *Dance of Death* (see illus. 4, 5, 11, 12), indiscriminate. It was a comfort to the poor that kings and princes would also suffer; it was an humbling lesson to prelates that they too would turn one day and look into the eyes of Death. But this aspect of the Church's teaching about death was a potential threat to the social fabric, as theology seemed to conflict with the prevailing political ideology. Subtle differentials of the rules of degree were ignored by Death, as was the wealth accumulated in life by the rich and powerful. Death's roughshod ride over the fine distinctions of social difference was as frightening as his challenge to continuity. The monumental body was, therefore, charged with the task of re-establishing social difference.

To do this, monumental bodies effected replacement of the deceased by registering what we might loosely term their personal identity and by locating them as precisely as possible in social terms, even at the cost of fabricating and manipulating history. In this project patrons and artists were challenged by those poets and divines who remained sceptical that monuments could satisfactorily preserve anything. For example, in his translations from Ovid and in other verses Henry Vaughan preached that words were a better memorial than monuments, since words

> ... can do more
> To keep thy name and memory in store
> Than all those *lordly fools* which lock their bones
> In the dumb piles of chested brass, and stones.[4]

In arguing for the material poverty of the natural body after death, Vaughan was putting forward a view that had been repeated over and over again since Antiquity.[5]

Class and rank were vital questions, not only when it came to designing an effigy but also when deciding where it should be set up. For the locations chosen for monuments of all kinds were ranked against a financial and social tariff. Individual parish churches operated charges governing the rights of burial in certain places: in the chancel, in a family chapel, in the nave, near the south porch, in a corner of the churchyard. Monuments, as markers of the place of burial, were permanent manifestations of this investment in space. Their very location was a sign of power:

> Here I lie by the chancel door,
> They put me here because I was poor;
> The further in the more you pay,
> But here lie I as snug as they.[6]

This verse from a Devon tombstone reveals an important truth about English funerary art. The tension which existed between the natural and the social bodies, that lack of a perfect overlap of meaning between the corpse and the aspects of the person after death, meant that what was paid for was never enough to preserve differentiation. However lofty the monuments of nobles, however glamorous the forms chosen by courtiers, however luxurious the decoration ordered by merchants, however subtle the inscriptions composed by scholars, however prestigious the heraldic quarterings displayed by knights, all such patrons knew that after death their natural bodies would be joined by those of the poor. We now need to see what it was that patrons expected to gain from the construction of commemorative art, what form these objects took, and how both patrons and artists set about having them made.

Once the question of the location of the monument was settled, the patron sought designs which suitably impressed the onlooker with the social significance of the person deceased. The crudest index by which commemorative art was thought to indicate the social importance of the deceased was through size. In the immediate post-Reformation period there was a noted increase in the number of monuments which sought to make their mark through enormous height. Size was regarded as so standard a token of status that there were complaints about the lower orders usurping the stations of their betters by building large tombs. Great height was desirable, as it guaranteed that the monument would remain in the eye of the congregation and catch the attention of the visitor. Height became even more desirable as the floor space was increasingly filled with monuments.[7] Such an aesthetic demands that, in the case of funeral monuments, we reconsider the standard objectives of Western art theory in the Classical tradition. In the late-medieval period, chantries, which were central to the Catholic death ritual but were illegalised in 1547, depended for their size on the wealth and power of the benefactor, and post-Reformation commemorative art seems to have taken up this principle.[8] In certain highly prestigious locations, for example the central London *mausolea* of Old St Paul's and Westminster Abbey (illus. 78), there seems to have been a latent competitiveness between the patrons; as a consequence, new monuments edged ever closer to the roof. Some buildings were simply too low to accommodate the monuments designed to be installed within them.

As might be imagined, building on this scale inside churches was not without its critics. Some objected on the grounds of liturgical convenience but others made more philosophical observations, revealing what it is that lies at the heart of the monument's function – its capacity to replace the deceased in society. Over-large monuments for people of only modest importance was not only an indiscretion and a break with what the rhetoricians called decorum; it was also a challenge to a system which maintained the cultural unity after death by using monuments that sustained an 'accurate' rendering of the deceased body. The most famous of these critics was the antiquary John Weever (1576–1632) who, in a series of pithy phrases, let fly a barrage of abuse at members of London's merchant classes, who were subverting the death ritual by building on a scale more appropriate to the nobility:

... for some of our epitaphs more honour is attributed to a rich quondam Tradesman or gripping usurer, than is given to the greatest Potentate.[9]

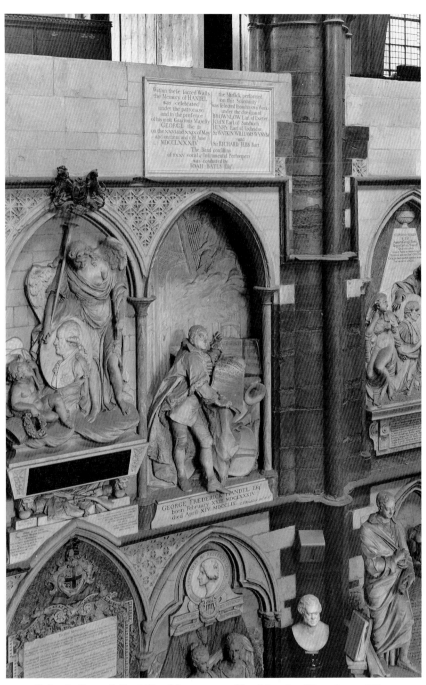

78. Louis-François Roubiliac, Monument to Handel, 1761. Westminster Abbey.

Some observers, it must be admitted, *were* impressed by great size: one noted of the Hertford tomb, 'a most stately monument as lofty as the roofe. The best works I ever yet saw'.[10]

In terms of their capacity to indicate the social body of the person commemorated, the materials used to make monuments were the subjects of an extremely complex economy. Each monument has to be considered entirely on its own merits – geographical, social and economic. Some materials were comparatively cheap and worked locally: wood for effigies and brass and slate for engraved panels; there were ledger stones and, by the late eighteenth century, cast-iron grave markers. Wooden figures are very much in a minority among surviving post-Reformation monumental effigies and are found scattered across the country in no logical pattern. Patrons appear to have ordered permanent wooden effigies if there was no suitable local stone of statuary quality; hence the groups of wooden effigies in the North-East, in Lancashire and in odd places in the South. Here, the local material is often a brittle limestone such as clunch, which would not have been suitable for armoured effigies requiring detailed surface work and vibrant decoration, or for any figure involving complex undercutting (illus. 79). Such chalky stuff would therefore seem a poor substitute for wood, which could more easily be sealed, primed and painted.

79. Monument to Thomas Plaifer (detail), polychromed freestone, after 1610. St Botolph, Cambridge.

80. Monument to an unknown knight, called Sir John de Hauteville.
polychromed wood, 14th century, refurbished 16th century.
St Andrew, Chew Magna, Avon.

XVII · KINDS OF MONUMENT

T he Chew Magna wooden effigy (illus. 80) is an especially complex object, unusual not only for its material but also for its pose. An amiable-looking lion acts as a heraldic retainer for the figure of an armoured knight who reclines on one elbow with eyes closed. His armour is medieval in design and the group rests on a plinth which, for many years, has displayed an inscription referring to an otherwise unknown knight, one Sir John de Hauteville, of Henry III's reign. From what appears to be original cutting to the back of the lion, the whole composition was designed to fit snugly into a niche rather smaller than that presently occupied. The unusual angle of the knight's leg and the eccentric semi-erect post of the lion suggest that the figure was originally designed to be seen, foreshortened, from below. The armour appears to be a sixteenth-century attempt to replicate the outmoded designs of the medieval period; it is designed as a

81. Brasses from Dunstable, Bedfordshire, commemorating the Fayrey family,
engraved brass, *c.* 1520.

conscious archaicism and uses a pose reminiscent of the medieval statues of the kings on the west front of Exeter Cathedral. Almost certainly, the Chew Magna figure is still further evidence of the important function that commemorative art had of reconstructing the historical past.

Compared to carved and decorated stone, let alone imported marble, brasses were quite cheap and easy to transport. The range of brasses produced in the sixteenth and seventeenth centuries was enormous; numbers dropped off in the eighteenth century, only to rise again with the Victorian revival of ecclesiastical craft-work. Brasses could be simple panels of incised inscription or complex groups of figures set onto stone. The material itself was relatively inexpensive, but during the sixteenth century prices dropped as large numbers of part-broken Flemish brasses were imported into London to be re-used on the reverse.[1] The standard late medieval type shows figures clothed and posed very much like the equivalent carved-stone figures from funeral monuments. Students of these brasses have also found evidence of another technique aimed at keeping down costs: mass production. Brasses were not intended to function as individual portraits of their subjects but rather as representations of types. The Fayrey brasses from Dunstable Priory now in the V&A show standard figures of this kind dating from around 1518 (illus. 81). Both male and female figures are in shrouds prior to burial, and their hands are clasped in prayer before them.

Elizabethan and Jacobean brasses included quite different kinds of subject-matter, for example complex allegories and domestic scenes. The

82. Richard Haydocke, Memorial to Humphrey Willis, engraved brass, after 1613. Wells Cathedral, Somerset.

83. Headstone to Susanna Symons, engraved slate, after 1729.
St James, St Kew, Cornwall.

former group relied on mottoes and other texts in Latin and in the vernacular, as well as various figurative motifs somewhat in the tradition of emblematic book illustration (illus. 82). The brass commemorating Humphrey Willis contrasts objects representing vanity – musical instruments, fashionable clothing and sports equipment set behind the kneeling figure – with, before him, the weapons of God which will bring the believer everlasting life. It is attributed to Richard Haydocke (d. 1641), who was not only a designer and an engraver but also a translator and scholar.[2] The 'domestic' type of brass followed very closely the iconographic changes in contemporary funeral monuments by setting out the family in order of rank for the beholder to admire. In certain areas of the country similar kinds of motifs were engraved in slate, for example in Cornwall where the native stone, granite, was unsuitable for figure carving but where good quality slate was plentiful (illus. 83). There are other enclaves of slate in the alabaster and freestone areas of England; in general, geological formations, as in other aspects of visual culture, were a deciding factor in the choice of materials and design.

The economy of the monuments becomes more intricate when materials had to be carried for long distances. A complex monument in Leicestershire made in London from high-quality materials, shipped along the coast and transported up-river (illus. 84), is quite a different object from a monument

84. Gerard Johnson and workshop, Monument to the 3rd Earl of Rutland, alabaster and imported 'marbles' with some original polychrome, 1591. St Mary, Bottesford, Leicestershire.

85. Monument to Alexander and Anne Denton, alabaster, *c.* 1567. Hereford Cathedral.

dragged across the country from Nottinghamshire to the Marches of Wales (illus. 85). Slate was not prized highly enough to make it worthwhile to transport long distances.

More complex monuments in carved stone, for example the Wyseman monument (see illus. 51), require particularly careful judgments. This elaborate wall monument makes use of English alabaster and what were called 'marbles', a combination that was extremely fashionable *c.* 1600. By then the centre of the tomb-making industry had moved from the alabaster beds of the Midlands to the fringes of the City of London, where it was to remain for the next three hundred years or so. In the Elizabethan period the majority of these Southwark tomb-makers were 'alien', that is, immigrants from the Low Countries and therefore prohibited from working or living within the area of the City itself. So they settled south of the Thames, and in the second and subsequent generations moved north and west to occupy premises between the City and Westminster in such parishes as St Martin- and St Giles-in-the-Fields and St George's, Covent Garden. The Wyseman monument was made in Southwark in the mid-1590s and transported in sections eastwards along the Thames and then north round the coast, perhaps to Maldon, to reach its destination at Rivenhall by ox-cart. Its simple design is suggestive of this mode of construction: carved in the workshop, then assembled and 'finished' on

site. It is a monument designed to occupy a limited floor space in the chancel of a country church of modest size. Determining its scale is the rectangular niche in the wall, which has to be wide enough to display the pair of life-size recumbent effigies. The other dimensions follow: the flanking pilasters with their pedestals are also between six and seven feet in height and in proportion to them is the entablature with its elaborate achievement-of-arms. The whole monument is raised a foot or so above the floor level by means of an ashlar step or basement. All these sections are clearly visible, and often where a monument has been badly affected by damp or hurriedly disassembled and incompetently put back together, these breaks in the construction are revealed (illus. 86).

The monumental body represented by the Wyseman monument can only be understood by reading four different systems of signification. This mature, English, post-Reformation monument comprised four interlocking sets of signs, all of which are on display in this example: figure sculpture; architecture and ornament; text; and heraldry. As the eye scans this composite image the signs operate together to create the necessary effect: the monumental body.

First comes figure sculpture, so often given priority in the literature of art history. Too often art historians separate the effigies from the monuments for which they were cut and treat them like an eccentric form of gallery figure sculpture. Contemporary references make it clear, however, that the effigies were regarded as a focus for the narrative. Documents register their high cost relative to the rest of the monument. At Rivenhall we are confronted by two kinds of figures: on a shelf across the middle of the monument are the two effigies of the main subjects, both with their feet to the east end of the church, their heads bare and their hands clasped. Their eyes are closed. They are both at prayer, laid out after death. The female figure is dressed in domestic costume with her head on an embroidered cushion; the male effigy wears the armour of a military man; his sword is at his side and his helmet is suspended on the wall above. He lies on a woven rush mat such as might be carried in a campaign.

Below these two effigies is a frieze of kneeling figures representing the children of the deceased. Such figures are carved on a scale much smaller than their parents even when they have reached adulthood, simply because they occupy a subsidiary social role. Here they are arranged in the usual way, by sex and age, with the males to the heraldic right. Around 1600, their kneeling pose was adopted for the main figures in some monuments, for example that to Lord Teynham at Lynsted, Kent (illus.66), or at Bradwell-juxta-Coggeshall where two generations of the Maxey family are

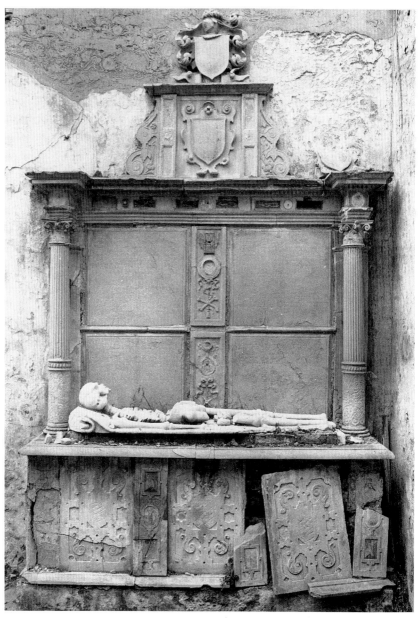

86. Monument to Thomas Blount and family, alabaster and freestone, after 1561.
St John the Baptist, Mamble, Hereford and Worcester.

87. Monument to two generations of the Maxey family, alabaster and imported 'marbles', late 1590s. Holy Trinity, Bradwell-juxta-Coggeshall, Essex.

represented in this way (illus. 87). Their scale is also determined by order of rank: the eldest of the three brothers is slightly larger than the otherwise identical figure behind him; a younger beardless brother is smaller still. They are all in fashionable civil dress with short capes allowing them to carry the swords which were signs of gentility, and they kneel in prayer on tasselled cushions. Their sisters are dressed very much like their mother and carved in high relief against the chest upon which the effigies of their parents lie. A simple index throughout the monument links the dead with the horizontal and the living with the vertical; priority is accorded to the male in terms both of heraldry and visibility.

The architecture and decoration surrounding these figures is quite simple and comparatively free of symbolism. Over the heads of the recumbent figures a canopy is supported on pilasters of no particular architectural order, although the existence of triglyphs engraved on the four brackets above suggest that, if anything, the Doric order may be implied. Coloured marble panels form pilasters set into lightly veined, whitish stone. Around 1600 such panels were usually black or perhaps in one of the imported coloured stones, such as the reddish-orange German stone called *rance*. The mouldings are all taken from the Classical canon in somewhat simplified vernacular forms. Apart from the triglyphs the only other decorative forms are a pair of finials on the cornice above and sets of rosettes which have been lost from the pilasters to the left and right. These

were perhaps originally in painted wood and have come adrift as the dowels which attached them have become weakened or rotted away. These simple Classical forms frame the effigies and support the heraldry: in other, more elaborate contemporary monuments, the designers combined more complex shapes from similar sources with different resonances, the triumphal arch motif being the most impressive.

In the very centre of the composition is set an inscribed panel, the partly abbreviated text of which is carefully cut into the stone in Roman capitals of various sizes. It is in English, although many similar ones were in Latin. Set in straight lines with an eye to symmetry, its role is not primarily decorative. The inscription imparts information that is absolutely vital to our understanding of the monument and helps construct the monumental body of Raphe Wyseman. The information it contains can be broken down into the following strands of data:

(i) Wyseman is the lord of Rivenhall and the patron of the church;
(ii) He is the second son of one John Wyseman of Wimbushe;
(iii) His wife, Elizabeth (d. 25 July 1594), was the granddaughter of Sir Richard Rich, Baron Rich and Lord Chancellor;
(iv) Wyseman and his wife produced six children, whose names are listed.

We can best understand the significance of what is both absent and present in this text by moving directly to consider the fourth of the threads of signification we identified earlier, that is, the heraldry. Originally, this might have been the first to catch the beholder's eye: prominent at the top of the composition and more brightly coloured even than the figure sculpture. The achievement on the cornice comprises the Wyseman arms set within an ornamental surround, from which more rosettes have gone missing, and which in turn supports a helmet with a beast on its crest. Below, there is more heraldry. At the foot of the two recumbent effigies recline the supporters of, respectively, the Wyseman and the Barley families, the latter relatives of the Rich family who were commemorated in an elaborate wall monument at nearby Felsted about twenty years later (illus. 88).[3] Elizabeth Barley's arms are displayed a second time over her head on, in heraldic terms, the inferior, female, left. They appear again, quartered with the Wyseman arms on the superior, male, dexter side. These two coats-of-arms flank the inscription we have already considered.

What then is the character of the monumental body constructed by this complex of signals on a monument in a relatively remote Essex church? What is its meaning?

The Wyseman monument has very little to do with religious belief. Erected in a church to mark the site of the holy sacrament of burial, it is

88. Epiphanius Evesham, Monument to Lord Rich and his descendants, alabaster and imported 'marbles', *c.* 1620. Holy Cross, Felsted, Essex.

almost entirely secular in its iconography and in its composition. Its style of architecture would not have been familiar in any contemporary church building; there are no crosses on show, no texts looking forward to the joyful resurrection of the deceased, no scriptural quotations. It is also hardly moralizing in the conventional sense: no statues personify the virtues of the people commemorated, no text refers to good works of any kind. Death itself is hardly mentioned, beyond the short phrase in the inscription which refers to the demise of the subject's wife. The effigies appear to represent the bodies of the dead, but there are no symbols of the corruption of the natural body and none of the lesser, kneeling statues of the progeny carry skulls as tokens of their own or their parents' deaths. There are no hour-glasses and the sons and daughters do not so much as shed a tear. The Wyseman monument cannot be counted as a work of art that is 'about' religion or death.

Nevertheless, death played the key role in its making. When his wife died in July 1594, Raphe Wyseman decided that his dynastic interests demanded that a monument be established to the family. He therefore briefed a tomb-maker, who constructed an object to stand in the church

as a testimony to the secular business of securing a particular alliance through marriage and then establishing a progeny. Not all contemporary patrons were quite so hard-nosed about their priorities; however, the Wyseman monument's combination of heraldry, references to the status of the wife's family, the numbers, names and 'persons' of the progeny are all typical of one of the central preoccupations of post-Reformation English funeral monuments. This monument illustrates precisely the way that the monumental body acts to replace the social body and to stress and maintain social differentiation.

Not all monuments were designed in this form. Over the period of three hundred years covered in this essay many contemporary, fashionable interests and many minority types among the thousands of elaborate funeral monuments carved in stone can be identified. For example, around 1600 elaborate tombs began to be erected to a broader social range than hitherto, a trend that continued through to the nineteenth century. Men in what were used to be called the professional classes started to lay claim to monuments: judges and other lawyers, dons and clerics were prominent among them. John Southcotte (*d.* 1585) lies at Witham, a few miles from Rivenhall, in his judge's robes (illus. 89). Such subjects, all men and mostly of a scholarly bent, often had tombs which showed them half-length, as a kind of portrait bust. Writers, as in the famous tomb to Shakespeare in

89. Monument to John Southcotte and his Wife, alabaster.
St Nicholas, Witham, Essex.

Stratford-upon-Avon, might be shown pen in hand; clerics, in the act of preaching or consulting a devotional text. These portrait busts were often set high up on the wall, thus avoiding any extra burden on ever more crowded floor space. Such monuments are also overwhelmingly concerned with social differentiation and the accurate replacement of the deceased by a suitable monumental body.

XVIII · IMAGE THEORY

In the eighteenth century funeral monuments attempted more complex portrayals of emotion and family relations, and many treated the tragic deaths of wives and mothers in childbed.[1] Art history has often explained these more complex groups of figures that attempt different actions, poses and expressions as the direct result of greater anatomical assurance or the influence of better-known formal models in Continental or Antique sculpture. But this under-estimates the traumatic effect of sixteenth-century reforms on the theory of images, particularly those displayed in churches. Recent research has greatly increased our knowledge of Reformist image theory and the history of iconoclastic attacks on images.[2] The standard historical explanation used to be that the Reformation was a disaster for English art because it effectively ended a lively tradition of practice as well as causing the destruction of a huge amount of material.[3] Disruptions during the period of the Civil Wars and the Commonwealth that followed have often been regarded as the aftermath of the Henrician break with Rome, an embarrassing episode in our national history.

Two points must be made in response to this story. First, although much destruction took place it has been very poorly chronicled and the blame has all too often been misapportioned. Research would show that Victorian reformers were responsible for more damage than their radical Protestant forebears.[4] Second, the effect of the sudden ban on church images on the production and consumption of figurative art needs rethinking. The literal reading of the Second Commandment did not suddenly render all artists unable to treat the human figure, but it certainly made them rethink their stylistic formulas. Images were prohibited in part as a response to Papist abuses of miraculous statues and in part because certain

kinds of image were considered to encourage the ignorant or the unwary to worship in an idolatrous way. The orthodox view opposed this, claiming that a church image was simply a means of summoning up a picture of the Deity in the mind's eye, as an aid to devotion. Simple people worshipped statues, believing them to be holy and the source of salvation; so sinful was such idolatrous behaviour that church images of all kinds were regarded as simply too dangerous and in consequence were banned.

Yet, as we have seen, the Wyseman monument, by no means the subversive object of a papist's patronage, shows several images of different kinds – effigies, statues of a portrait type and heraldic beasts. Similar monuments show standing figures of Virtues, such as Prudence (illus. 90), allegorical figures representing, for example, Faith, as well as symbolic

90. Cornelius Cure, Monument to Sir William Cordell (detail of personification of Prudence), alabaster and imported 'marbles', after 1580.
Holy Trinity, Long Melford, Suffolk.

images such as Death – often shown with his hour-glass and scythe in the tradition of the *memento mori*. This kind of statuary was permitted on church funeral monuments as a result of an elaborate defence against accusations of idolatry set up by the state under Elizabeth and again under Cromwell. The Anglican theory of images was established behind the defence of the Lutheran theory of *memoria*: funeral monuments showing figures were legitimate because they were not representations of religious figures and because they were intended to act as examples to the onlooker. The Wyseman monument gives us some idea of the kinds of virtues and contributions and achievements that were regarded as exemplary. This was the important principle which was fully developed in English monumental sculpture over the centuries that followed the Reformation, and which we are familiar with in the cases of memorials to the dead of two world wars.

But the fear of accusations of idolatry did not only affect the choice of an iconographic programme, that is, the decision taken by the patron and the tomb-maker about which figures to include. It also affected what later discourse has come to call 'style' – i.e. the manner in which the medium of the sculpture was manipulated to produce a particular form. Arguments placed by the Reformers who encouraged iconoclastic attacks on idolatrous images, and who wanted to prohibit even monumental effigies, included the view that the artifice required to make such images was in itself illegal in the eyes of God, whose creativity humans could not rival in making figures. This was a complaint against artists whose search for naturalistic effects could appear to be an attempt to replicate God's own creation. A long tradition had presented God as the 'first sculptor', shaping the human form in the body of Adam with Himself as the model. In the generations after the Reformation, sculptors and patrons were uncertain about figures, especially those to be displayed in churches, and it was only when the exemplary tradition of *memoria* was fully established in the middle years of the seventeenth century that designers could once more risk displaying a full range of effects on monuments. Sculptors could only rival Nature's or God's art when the results could no longer be confused with the works of the Devil. No one could accuse the unknown carver of the Wyseman effigies of being a rival to God, the First Maker.

Simpler kinds of commemorative art, designed to be set up in less prestigious locations, were usually made of materials to hand. Much of this art was only concerned about marking the grave with a straightforward message, such as the name and dates of the deceased. Headstones, such a familiar feature of the typical English churchyard, seem only to have been used from the later seventeenth century onwards.[5] Until the twentieth

91. Memorial to Maria Forbes, local stone, post-1655. Churchyard of SS Peter and Paul and St Thomas of Canterbury, Bovey Tracey, Devon.

92. Memorial to Jane and Barbara Knight, cast iron, after 1705. Churchyard of St George, Burrington, Hereford and Worcester.

century the production of headstones and other stone markers was a comparatively local business (illus. 91). Recent research, however, has revealed an extensive market in cast-iron grave-markers from the late eighteenth century and larger slabs from even earlier (illus. 92).[6] The stock-in-trade of such memorials was a restricted repertory of symbols: the cross, the skull-and-crossed bones, cherubs, hour-glasses and perhaps a scythe. The development of cast-iron technology and the distribution of stock commemorative items over a wide geographical area may perhaps be likened to the production of commemorative carving in the Purbeck quarries of Dorset from the mid-twelfth century into the late sixteenth and after.[7] Painted pictures were also employed as commemorative objects and could take on most of the functions of stone and other three-dimensional monuments, except perhaps the acquisition of that air of permanence regarded by the poets as so vainglorious. The herald-painters, such as the Holme family, were active in this field.

Other objects were part of a national and even an international trade. The late-medieval Midlands alabaster business, which had traditionally supplied most of the high quality native effigies, was quite rapidly replaced by a luxury import-led business centred on London which has survived unchanged to this day. Jacobean gentlemen were lured by the smooth finish of foreign marbles just as present day monumental masons seem obsessed by the immaculate surface effects of so-called exotic granites.

The designs imposed on these materials were determined by the ritual demands of function and iconography. These, for example, explain how a set of monuments to members of one family in an aisle of the local parish church all make use of the same composition, decoration and style of inscription. The side chapel containing a half dozen monuments to members of the Sylvester family at Burford, Oxfordshire, is a case in point (illus. 93). Innovation is not necessarily what is required in constructing the family history that this group of monuments represents. Expecting what today's concept of art connotes, variety and invention seem to have been so patently lacking when this series of monuments was being made. This, however, would be to look for 'art' where 'visual culture' resides. As in a set of ancestor portraits displayed in a gallery, the replication of an earlier monument's design might well have been an attempt to suggest a continuity of lineage; it should not therefore be written off as evidence of the artist's lack of inspiration.

Elaborate patterns of patronage are typical of post-Reformation commemorative art and they suggest just how closely the material culture of the death ritual was attached to its social base. Families were acutely

93. Monuments to members of the Sylvester family, freestone, 1588–1654.
St John the Baptist, Burford, Oxfordshire.

conscious of precedent and tradition; newly-rich landowners showed them-
selves recumbent on tomb-chests, and thus paid special attention to
questions of hierarchy and decorum in their efforts to construct monumen-
tal bodies that would appear authentic and act as permanent replacement
for their subjects (illus. 94).

Transactions between the tomb-maker and the patron were often a
complex business deal, taking account of cost, the time allowed for com-
pletion and close specifications as to materials, size and even decoration.

Increasingly, artists themselves used three-dimensional models to give their patrons a firmer idea of how the monuments would look after installation and decoration. In the sixteenth and early seventeenth centuries such patterns took the form of drawings, often coloured in, but towards the end of the seventeenth century a model in wood, plaster or some other mouldable substance became the norm for complex monuments (illus. 95–98).[8] Patrons were also responsible for supplying tomb-makers with the texts of the inscriptions to be included and details of the heraldic devices. As we have seen, lines of engraved text were an essential component in programmes of post-Reformation English monuments and were not in any way regarded as potentially subversive of the whole design enterprise. Only the conventions of later art history have found the text to be damaging to the illusory figural integrity of monumental art.

All these devices helped commemorative art to sustain continuity in the culture, and they made the monumental body a more effective, more accurate replacement of the natural body. They tied families, places and histories together in an apparently seamless web of continuity that still characterizes for so many people the local history of England. The fact that so many of these histories were artificially contrived in no way denies their effectiveness; indeed, it proves the power of the monumental body.

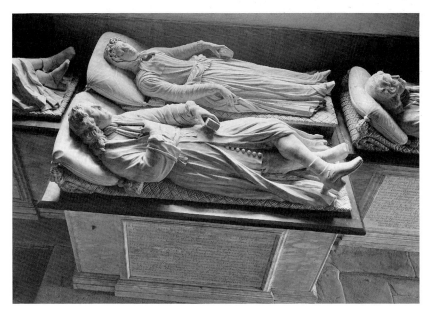

94. William Stanton, Monument to Richard Sherburne and his wife, Isabel, *c.* 1699. All Hallows, Great Mitton, Yorkshire.

95. Preparatory drawing for the Monument to Thomas Throckmorton,
pen and ink, *c.* 1612.

96, 97. Louis-François Roubiliac, Models for the Monument to John,
2nd Earl of Montagu, (*above*) terracotta,
(*below*) painted wood and plaster, *c.* 1750–52.

98. Workshop of John Bacon II, Drawing for a Monument to Elizabeth Bacon,
wife of John Bacon, R. A.

XIX · EPILOGUE

Since the sixteenth century antiquaries and historians such as Leland, Camden, Hearne and Aubrey have used inscriptions on English monuments as sources of data for family and county histories. As the political situation grew ever more tense in the mid-1640s, Sir William Dugdale toured the country with an artist and made careful notes, drawings and transcriptions of sculpture, heraldry and texts (illus. 99).[1] Other scholars collected data from monuments even during the hostilities: Richard Symonds's diary of his activities in the West Country and the Welsh Marches is a particularly good example.[2] By the early eighteenth century the great task of compiling definitive collections was well under way; the manuscripts in the Le Neve group in the British Library contain many thousands of examples.[3]

The antiquaries treated monumental art as an historical source. In recognizing that monuments constituted a kind of historical fact, their approach was not substantially different from the patrons who had erected the monuments in the first place. As did the death ritual, the remains of the past were expected to instruct the present in how to behave. In its stress on exemplification, history was an overtly didactic discourse. During the eighteenth century British artists began to paint and sculpt didactic, moralizing themes from the Classical canon. One of the most significant was the subject given the title 'Et in Arcadia Ego', after the inscription deciphered on an anonymous ancient tomb by travellers who were thereby confronted by their own mortality. There is tremendous depth to the tradition of contemplating one's own existence in response to a confrontation with commemorative art; the subtitle of Thomas Gray's *Elegy* – 'Stanzas Wrote in a Country Church-Yard' – is one of the most famous identifications in the history of English poetry.[4] Since the Reformation, painters and poets have virtually assumed the capacity of monuments and ruins to be evocative:

> I doe love these auncient ruynes:
> We never tread upon them but we set
> Our foote upon some reverend History . . .[5]

In the process of dying that is at the heart of the ritual, death is the subject of meditation in the course of life. As do ruins, inscriptions on

99. Wenceslaus Hollar, 'Monument of John Colet', etching from Sir William Dugdale's
History of St Pauls, 1658.

100. Enamelled earthenware, *c.* 1780, after the Monument to William Shakespeare
by William Kent and Peter Scheemakers in Westminster Abbey.

tombstones expect to be read by people of sensibility wandering through the world in search of meditative inspiration. The epitaph may begin, 'Stay Passenger / And know who lies beneath this stone',[6] but once the reader's feelings are engaged, he or she is taught history as a means of moral improvement.

It lay within the conventions of this historical discourse to invent the objects of instruction. In the early years of the eighteenth century English patrons first encountered a genre of invented pictures – the allegorical tombs of Owen McSwiny.[7] This notorious entrepreneur arranged for teams of famous Italian artists to collaborate on a set of pictures dedicated to the memories of formerly prominent individuals.[8] The Duke of Devonshire's monument by Sebastiano and Marco Ricci (illus. 101) shows a fantastic caprice, with no consistent geographical or historical referents. The ruined architectural setting is slowly overtaken by Nature as the assorted audience of Ancients, Moderns, philosophers, courtiers and Arcadians contemplate a gigantic monument erected in Devonshire's honour. The iconography of the fictive sculpture on the tomb makes a play on traditional allegory by referring to the subject's virtue and to the family heraldry. Below, a damaged river god perhaps signifies the broken family lineage.

In post-Reformation England the aims and intentions of the death ritual were established and confirmed by a visual culture which allowed for the diverse construction of the human body at death. We have seen how pictorial images played an important part in the tradition of the *memento mori* and prepared the believer for death. To make concrete the ephemeral impressions of the funeral ceremony images were shaped in particular styles and materials, and effigies replaced the decaying natural body on funeral monuments to create permanent histories of the deceased. Those who remained – the bereaved – surrounded themselves with visual signs in their homes, in their costume and on their persons to sustain the memory and the very presence of the dead. This practice was not morbid but therapeutic. As social historians have long argued, the higher mortality rate and the shorter life expectancy probably contributed to the general sense that death took place among the living in a way that is no longer true. The state helped maintain its authority over the living by controlling the visual culture of the death ritual. Industrialization and mass urbanization towards the end of the eighteenth century seem gradually to have generated out of the shell of the post-Reformation ritual a new pattern in which visual culture still played its part. Some of the devices and traditions of the earlier ritual were developed and refined to accommodate the

101. Sebastiano and Marco Ricci, *Ideal Monument to William Cavendish, 1st Duke of Devonshire*, oil on canvas, early 18th century.

demands of new social circumstances: the mass societies of the nineteenth century. Funerals were still theatrical public displays; mourning was ruthlessly and ever more selfconsciously observed and monuments were designed to express the achievement of their subjects in an ever more individualized language. It seems clear, however, that the Victorian ritual tended to stress the abnormality and the deep difficulty of death; whereas the final aim of the earlier ritual was to place death in life in order to soften its blow. Although it is dangerous to be tempted by neat period generalities it seems clear that the post-Reformation ritual recognized the cultural complexity of death, while the later ritual denied it.

Our own culture tends to understate the need for ritual complexity in this matter and is inclined to deny the potential psychological damage of bereavement. Among us, death happens in institutions and the bodies of the dead are hidden from view. To accompany its negative connotations the ritual of death has become ever more muted, its signals ever more bland. Few of the material artefacts produced for present day ritual demand any skills in design, or subtleties of reading on the part of the onlooker. Victorians lingered over death but could not bring themselves to recognize the public existence of sexual relations; in the later part of the twentieth century sex gradually became a subject for open discussion, but death seems more deeply buried than ever. Sex and death: the transitory points in human existence which, in many cultures, are seen as rites of passage of equal importance. Possibly the increasingly negative connotations of sex, accumulating as a result of the AIDS epidemic, may gradually transform our attitude towards the rituals of death. A study of the visual culture of the post-Reformation death ritual shows, however, that this has yet to happen.

REFERENCES

INTRODUCTION

1 From 'Death', *The Complete Poems*, ed. A. Rudrum (Harmondsworth, 1976), p. 302. See also George Strode, *The Anatomie of Mortalitie* (London, 1628), p. 55.

I · THE OBJECT OF COMMEMORATION

1 D. J. Enright, ed., *The Oxford Book of Death* (Oxford, 1983), p. 293. On samplers see D. King, *Samplers*, Victoria & Albert Museum (London, 1960).

2 As a challenge to the Italianate interpretation of Northern art see Svetlana Alpers, *The Art of Describing: Dutch Art in the Seventeenth Century* (Chicago, 1983). For England see Maurice Howard and Nigel Llewellyn, 'Painting and Imagery', *Renaissance and Reformation*, ed. Boris Ford; volume III of the Cambridge Guide to the Arts in Great Britain (Cambridge, 1989), especially pp. 223–5.

3 Peter Murray, *The Dulwich Picture Gallery: A Catalogue* (London, 1980). The version of the inscription given here has been modernized.

4 Elizabeth Honig, 'Lady Dacre and Pairing by Hans Eworth', *Renaissance Bodies: The Human Figure in English Culture, c.1540–1660*, ed. Lucy Gent and Nigel Llewellyn (London, 1990), pp. 71–5.

5 Enright, *op.cit.*, p. 4.

6 See N. Pevsner and E. Williamson, *The Buildings of England: Derbyshire* (2nd edn, Harmondsworth, 1978), p. 350 and plate 45.

7 John Hayes, *Thomas Rowlandson: Watercolours and Drawings* (London, 1972), pp. 184–5, 201; for the second of these subjects, see also Ronald Paulson, *Rowlandson: A New Interpretation* (New York, 1972), pp.13–14.

8 O. Millar: *The Age of Charles I: Painting in England, 1620–1649*, Tate Gallery exhibition catalogue (London, 1972), p. 102 and plate 161.

II · RITES OF PASSAGE

1 The key text here is Robert Hertz's essay 'Death', first published in 1907. The literature on the anthropology of death is extensive, but for this analysis see Arnold Van Gennep, *The Rites of Passage*, trans. M. B. Vizedom and G. L. Caffee (London, 1960); Maurice Bloch and J. Parry, eds, *Death and the Regeneration of Life* (Cambridge, 1982); Phillippe Ariès, *The Hour of Our Death*, trans. H. Weaver (London, 1981).

2 Richard Hooker, *Of the Laws of Ecclesiastical Polity*, V, xlvi, ed. C. Morris (London, 1907), II, pp. 179–81. For Donne's will see Public Record Office, London, P.C.C. 46 St John, proved 5 April 1631.

3 Roy Strong, 'Sir Henry Unton and his Portrait: An Elizabethan Memorial Picture and its History', *Archaeologia*, xcix (1965), pp. 53–76 and Strong, *National Portrait Gallery: Tudor and Jacobean Portraits* (London, 1969), I, pp. 315–9, and II, plates 627–34.

4 Robert Wright, ed., *Funebria nobilissima ad praestantissimi equjitis D. Henrici Untoni* (Oxford, 1596).

5 Dudley Carleton to John Chamberlain, cited by Diana Poulton in *John Dowland* (2nd edn, London, 1982), pp. 423–4 (English modernized).

6 See Poulton, *op.cit.*, chapter V and *passim*.

III · DYING, A PROCESS

1 What remains of this monument is now in storage in the Old Muniment Room at Hereford Cathedral. Its original form, as seen from the north transept, is just visible in James Storrer, *The History and Antiquities of the Cathedral Churches of Great Britain* (London, 1816), II, plate V.

2 Grinling Gibbons's patron Tobias Rustat seems to have kept his monument in his rooms at Jesus College, Cambridge, for at least eight years before his death in 1693; see M. D. Whinney, *Sculpture in Britain, 1530–1830*, rev. edn by John Physick (Harmondsworth, 1988), pp. 58–9.

3 H. B. Wright and M. K. Spears, eds, *The Literary Works of Matthew Prior*, 2 vols (Oxford, 1959). Many other poets have written their own epitaphs.

4 *Castle Rackrent*, ed. G. Watson (London, 1964), p. 81. Rowlandson's drawing *Dead Alive*, bears some similarity to the theme of Edgeworth's story (see Hayes in § I, note 7).

5 The full title of West's treatise is *Symbolaeographia, which may be terms the art, description, or image of Instruments, Covenants, Contracts etc. or the Notorie or Scrivener.*

6 British Library, London, Harleian MS 1498.

IV · DANCES OF DEATH

1 Mary O'Connor surveys this considerable body of literature in *The Art of Dying Well: The Development of the 'Arts Moriendi'* (New York, 1942).

2 Hilda M. R. Murray, ed., *Erthe upon Erthe . . .*, Early English Text Society, original series cxli (London, 1911).

3 Margaret Aston, *England's Iconoclasts, I: Laws Against Images* (Oxford, 1988).

4 The literature on the 'Dance of Death' is immense: see J. M. Clark, *The Dance of Death in the Middle Ages and the Renaissance* (Glasgow, 1950), and several extremely useful recent studies in German: *Bilder und Tänze des Todes: Gestalten des Todes in der europaischen Kunst seit dem Mittelalter* (Unna and Paderborn, 1982) and *Totentänze aus sechs Jahrhunderten* (Ratingen, 1982), both of which are exhibition catalogues, and E. Koller, *Totentanz: Versuch einer Textemberschreibung* (Innsbruck, 1980). For Rowlandson's *English Dance of Death* see Hayes in § I, note 7.

5 Hayes, p. 199.

6 W. Rotzler, *Die Begegnung der drei Lebenden und der drei Toten* (Winterthur, 1961).

7 See the useful Introduction to W. L. Gundersheimer's edition in facsimile (New York, 1971) and more recently and more generally John Rowlands, *Holbein: The Paintings* (Oxford, 1985), pp. 60–61.

8 In the Pinakothek, Munich.

9 In England Holbein's designs were the source for countless variants besides Rowlandson's, from Wenceslaus Hollar's of 1647 to the fifty-two woodcuts in Thomas Bewick's *Emblems of Mortality* (1789).

10 From 'The Realms of Death' in *The English Works of Sir Thomas More* (London, 1931), pp. 467–8.

11 This notion of the different aspects of the body at death is examined more closely in § VII. It is a division suggested by the title of the first Lyon edition of Holbein's *Dance of Death*:

'*Les simulachres & historiées de la mort . . .*' ('Images and illustrated facets of death . . .').

12 Alan Watts, *Myth and Ritual in Christianity* (London, 1954), p. 207.

V · EXAMPLES OF VIRTUE

1 On Purgatory and *memoria* see O. G. Oexle, 'Die Gegenwart der Toten', *Death in the Middle Ages*, ed. H. Braet and W. Verbecke (Leuvan, 1983), pp. 70–71.

2 Lawrence Stone, *The Family, Sex and Marriage in England, 1500–1800* (London, 1977), a book which has generated a great deal of discussion; see reviews by Alan Macfarlane, *History and Theory*, xviii (1979), p. 103, and Keith Thomas, *TLS* (21 Oct 1977), p. 1226.

3 The monument to John Faldo (*d* 1613, aged 10) at West Ham, London, refers to him as '*Pius, generosus et eruditus*' ('Pious, of good birth and learned'); Arthur Heselrigge (*d* 1649, aged 11) at Noseley, Leicestershire, was of 'regular witt . . . of sweet nature and very pieus [*sic*]'.

4 Monumental inscriptions praising the virtues of young girls play on similar themes: 'So to prevent all my insuing crimes/Nature my nurse laid me to bed betimes' (from the monument to Margaret Clarke, *d* 1640, Salford Priors, Warwickshire).

5 For the attitude to such paintings in England see John Barrell, *The Political Theory of Painting from Reynolds to Hazlitt: 'The Body of The Public'* (London and New Haven, 1986).

6 See Reynolds's arguments in favour of Antique costume in the *Discourses on Art*, ed. R. R. Wark (London and New Haven, 1975), pp. 186–7.

7 Benedict Nicolson, *Joseph Wright of Derby: Painter of Light* (London, 1968), I, pp. 65–6; for the engraving made after this picture see Judy Egerton, *Wright of Derby*, Tate Gallery exhibition catalogue (London, 1990), pp. 254–5. For the entry on *The Old Man and Death* see Egerton (1990), pp. 83–4.

8 Murray, *Dulwich Portrait Gallery*, supplemented by Aubrey, *Brief Lives*, ed. O. L. Dick (Harmondsworth, 1972), pp. 259–61.

VI · DEATH, A BAD BUSINESS

1 Nicholas Penny, ed., *Reynolds*, Royal Academy exhibition catalogue (London, 1986), pp. 294–5.

2 Rosalie Ormond, 'Body and Soul Dialogues in the Seventeenth Century', *English Literary Renaissance*, iv (1974), p. 363, and R. Woolf, *The English Religious Lyric in the Middle Ages* (Oxford, 1968), pp. 89–102, 326–30.

3 Brian Allen, *Francis Hayman*, Iveagh Bequest, Kenwood, exhibition catalogue (London, 1987), p. 139.

4 This theme of the substance of the soul differing from that of the body is constantly alluded to in sevententh-century literature, especially in the work of Henry Vaughan and other 'Metaphysical' poets.

5 R. Huntington and P. Medcalf, *Celebrations of Death: The Anthropology of Mortuary Ritual* (Cambridge, 1979).

6 Joyce Youings, *Sixteenth-Century England* (Harmondsworth, 1984), p. 112; for the hierarchy of execution see p. 221.

7 For more on this see Nigel Llewellyn, 'The Royal Body: Monuments to the Dead, For the Living', in Gent and Llewellyn, *Renaissance Bodies*, pp. 218–40.

8 Martin Kemp, ed., *Dr William Hunter at The Royal Academy of Arts* (Glasgow, 1975).

9 D. Hay, ed., *Albion's Fatal Tree: Crime and Society in Eighteenth-century England* (Harmondsworth, 1975).

1 On the *transi* see Pamela King, 'The English Cadaver Tomb in the Late Fifteenth Century', *Dies illa: Death in The Middle Ages*, ed. J. M. H. Taylor (Liverpool, 1984). Such imagery was deployed in verbal forms by authors of *ars moriendi*, for example Jeremy Taylor, *The Rule and Exercises of Holy Dying* (London 1651).

2 See Llewellyn, 'The Royal Body', *op. cit.*

3 The standard account of this important theory is E. H. Kantorowicz, *The King's Two Bodies: A Study in Medieval Political Theology* (Princeton, 1957).

VIII · BODY LANGUAGE

1 This is a constant theme in social history, for example M. E. James, 'Two Tudor Funerals', *Society, Politics and Culture: Studies in Early Modern England* (Cambridge, 1986).

2 See, for example, the useful Introduction in *Mirrors of Mortality: Studies in The Social History of Death*, ed. Joachim Whaley (London, 1981).

3 A useful, short introduction to his work is Jonathan Culler, *Saussure* (London, 1976).

4 There are dozens of introductions to and studies on this subject, for example Richard Harland's useful survey of the field, *Superstructuralism: The Philosophy of Structuralism and Post-Structuralism* (London, 1987).

5 See Edmund Leach, *Lévi-Strauss* (rev. edn, London, 1974). As an introduction to Lévi-Strauss's work, see the essays collected under the title *Structural Anthropology* (Harmondsworth, 1968).

6 An English translation of *Tristes Tropiques* has since appeared (London, 1973).

7 For some examples of this see the recent issue, 'The Verbal and Visual Sign', of *Word and Image*, vi/3 (1990), guest edited by Gillian Mayo.

8 See Margaret Iversen, 'Models for a Semiotics of Visual Art', *The New Art History*, ed. A Rees and F. Borzello (London, 1986).

9 Brian Hurwitz and Ruth Richardson, 'Jeremy Bentham's Self Image: An Exemplary Bequest for Dissection', *British Medical Journal*, ccxcv (1987), pp. 195–7, and, in greater detail, Ruth Richardson's magisterial treatment, *Death, Dissection and the Destitute* (2nd edn, Harmondsworth, 1989).

10 Richardson, *passim*.

11 As happened during World War I, when it was decided that the bodies of the fallen should remain abroad. I have learned about the effects of this decision on commemorative art from the current research of Catherine Moriarty, a graduate student at the University of Sussex.

IX · THE NATURAL BODY AND ITS FATE

1 Cennino d'Andrea Cennini, *The Craftsman's Handbook: The Italian 'Il Libro d'Arte'*, ed. D. V. Thompson (New York, 1960), pp. 124–7. For death-masks there is little more recent than E. Benkard, *The Undying Face* (London, 1929). There has been a lively debate on the relationship between the natural body, the mask, the funeral effigy and the monumental effigy and about the status of the latter as portrait; see R. P. Howgrave-Graham, 'Royal Portraits in Effigy: Some New Discoveries in Westminster Abbey', *Journal of The Royal Society of Arts*, ci (1952–3), pp. 465–74, and more recently Carol Galvin and Philip Lindley, 'Pietro Torrigiano's Portrait Bust of King Henry VII', *Burlington Magazine*, cxxx (1988), pp. 892–902. John Evelyn visited a plasterer at Charing Cross on 10 February 1669 to have his life-mask taken.

2 W. St John Hope, 'On the Funeral Effigies of the Kings and Queens of England', *Archaeologia*, lx/2 (1907); L. E. Tanner and J. L. Nevinson, 'On Some Later Funeral Effigies in Westminster Abbey', *Archaeologia*, xcviii (1961); R. E. Giesey, *The Royal Funeral Ceremony in Renaissance France* (Geneva, 1960).
3 Mary Edmond, 'Limners and Picturemakers . . .', *Walpole Society*, xcvii (1978–80), pp. 162–4.
4 W. St John Hope, p. 540.
5 *Ibid.*, p. 555.
6 Terms we shall have to consider in greater detail in due course.
7 Richardson, *passim*.
8 Robert Southwell in D. J. Enright, ed., *The Oxford Book of Death*, p. 25.
9 J. Charles Cox, *Churchwardens' Accounts From the Fourteenth to the Close of the Sixteenth Centuries* (London, 1913), pp. 172–3.
10 This example was kindly brought to my attention by Roger Boudler.
11 On such customs see Margaret Baker, *Folklore and Customs of Rural England* (London, 1974), and the extensive bibliography in the best recent work on the subject, Clare Gittings, *Death, Burial and the Individual in Early Modern England* (London, 1984).

X · FUNERALS: THE DECLARATION OF DIFFERENCE

1 For funerals see Gittings, *passim*, and Keith Thomas, *Religion and The Decline of Magic: Studies in Popular Beliefs in Sixteenth- and Seventeenth-century England* (London, 1971), p. 718ff.
2 Gittings cites a two month gap in the case of the Duke of Richmond and Lennox in 1624 (p. 167).
3 British Library, Add. MS 2129, f.27ʳ. For other examples of such rules see College of Arms, London, MS S. M. L./28; B.L. Cotton MS Julius B.xii; Nicholas Charles, Lancaster Herald, 'Book of proceedyng at Funerals, 1613' in B.L. Add. MS 14417; B.L. Harl. MS 2129, f.27ʳ; and other MSS cited by Gittings, p. 243.
4 See Paul S. Fritz, 'From "Public" to "Private": The Royal Funerals in England, 1500–1830', *Mirrors of Mortality*, ed. Whaley, p. 76. Vincent's rules are in the College of Arms, London, MS Vincent 151.
5 Anthony Wagner, *Heralds and Ancestors* (London, 1978), pp. 66–7.
6 Again, the literature on this subject is immense. For a basic bibliography see Wagner, p. 86.
7 Robert Tittler, *Nicholas Bacon: The Making of A Tudor Statesman* (London, 1976).
8 Thomas Becon, 'The Sicke Mans Salve' in *Prayers and Other Pieces*; see J. Ayres, ed., *Collected Works* (Cambridge, 1884), II, p. 125.
9 Wagner, p. 70, plate 25 and erratum slip.
10 Gittings, p. 174.
11 J. Charles Cox notes an account for the replacement of iron hearses (p. 170).

XI · HERALDIC DISPLAYS

1 From *Applebee's Original Weekly Journal* (11 Aug 1722), p. 2438.
2 M. S. Giuseppi, 'The Work of Theodore De Bry . . .', *Proceedings of the Huguenot Society*, xi (1915–17), pp. 204–26.
3 On Sidney's death see John Buxton, 'The Mourning for Sidney', *Renaissance Studies*, iii (1989), pp.46–56, and on the plans for the monument see Nigel Llewellyn, 'Claims to

Status through Visual Codes: Heraldry on post-Reformation English Funeral Monuments', *Chivalry in the Renaissance*, ed. S. Anglo (Woodbridge, 1990), pp. 145–60.

4 Buxton examines this argument and offers further references (p. 50).

5 Roy Strong, *Gloriana: The Portraits of Queen Elizabeth I* (London, 1984).

6 Gerard Legh, *The Accedens of Armorie* (London, 1562), sig. 178.

7 Segar, who wrote *Of Honor Militarie and Civill* (London, 1602), was Garter King of Arms from 1607. His prefatory poem to John Guillim's *A Display of Heraldrie* (London, 1610) attacks, as socially subversive, Puritan complaints about heraldry.

8 *The Academy of Armorie, or A Storehouse of Armoury and Blazonry* (London, 1688) was written by Randle Holme III.

XII · FUNEREAL PARAPHERNALIA

1 J. Charles Cox, p. 54.

2 For embroidered examples see *Opus Anglicanum: English Medieval Embroidery*, Arts Council/V&A exhibition catalogue (London, 1963). Although recusant Catholic funerals must have continued in secret after the Reformation statutes were passed, I know of no substantial study of them; by their very illegality, they are likely to be badly documented.

3 Rowland Johnson, *The Ancient Customs of the City of Hereford* (London, 1868), pp. 159–60, citing John Aubrey (p. 90).

4 From a card in the collection of the Hon. Christopher Lennox-Boyd, whom I would like to thank for allowing me to see some remarkable material.

5 Paul S. Fritz records one William Russell, a painter-stainer who started 'undertaking' in the 1680s (*Mirrors of Mortality*, p. 76).

XIII · LITURGIES

1 See Joachim Whaley's account of Lutheran beliefs in this respect in *Mirrors of Mortality*, p. 83.

2 S. Denison, *The Monument or Tombe-stone, or, A Sermon Preached at the Funeral of Mrs E. Juxon* (London, 1620), p. 73.

3 Henry King, 'My Midnight Meditation', *The Metaphysical Poets*, ed. Helen Gardner (2nd edn, Harmondsworth, 1972), p. 114.

4 See Henry King, 'The Exequy: To his Matchlesse never to be forgotten Friend' (his wife, Anne Berkeley, who died in 1624), *The Metaphysical Poets*, pp. 110–13: 'My pulse like a soft Drum / Beats my approach, tells *Thee* I come' (p. 113).

6 British Library, Harleian MS 7340, f.3. The words are Thomas Tudway's, a collector of church music.

XIV · WORN OUT AND IN

1 N. B. Harte, 'State Control of Dress and Social Change in Pre-Industrial England', *Trade, Government and Economy in Pre-Industrial England*, ed. N. B. Harte *et al.* (London, 1976).

2 For this and other similar details see Lou Taylor, *Mourning Dress: A Costume and Social History* (London, 1983), a book from which I have learnt much.

3 Shirley Bury, *Sentimental Jewellery*, Victoria & Albert Museum (London, 1986); Diana Scarisbrick, 'A Becoming Mourning', *Country Life*, clxxxiv (18 Jan 1990), pp. 58–60.

4 J. T. Micklethwaite in the *Proceedings of the Society of Antiquaries*, 2nd series xx (1903–5), pp. 60–62.

5 G. E. P. and J. P. How, *English and Scottish Silver Spoons* (London, 1952), I, 308–9.

6 Kauffmann invented a series of archetypal mourning pictures showing historical figures such as George Washington, fictional characters such as Goethe's Charlotte, who mourns over the tomb of Young Werther, as well as Shakespeare.

7 British Library, Add. MS 35324.

8 Roy Strong, *The English Icon: Elizabethan and Jacobean Portraiture* (London, 1969), p. 31; on the question of black as the standard colour associated with death see Huntingdon and Medcalf, *Celebrations of Death*, p. 45.

9 J. H. Baker, 'History of Gowns Worn at the English Bar', *Costume*, ix (1975), pp. 15–21.

10 Baker, ibid.

11 See *The Barbara Johnson Album of Fashion and Fabrics*, ed. Natalie Rothstein (London, 1987).

12 A. S. Hirschorn, 'Mourning Fans', *Antiques*, ciii (1973), pp. 801–4.

XV · OBJECTS OF MOURNING

1 John Morley, *Death, Heaven and the Victorians* (London, 1971); L. D. Ettlinger, 'The Duke of Wellington's Funeral Car', *Journal of the Warburg and Courtauld Institutes*, iii (1939–40), pp. 254–9.

2 Anita Schorsch, *Mourning Becomes America: Mourning Art in the New Nation*, William Penn Memorial Museum exhibition catalogue (Harrisburg, Pa., 1976).

3 Alison Yarrington, 'Nelson the Citizen Hero: State and Public Patronage of Monumental Sculpture, 1805–18', *Art History*, vi (1983), pp. 315–29.

4 See Bury, *Sentimental Jewellery*.

5 Ibid.

6 Murray, *Dulwich Picture Gallery*, p. 62.

7 See the lament in Shakespeare's *Othello*, IV, iii.

8 See Sir Thomas Browne's famous reflections, *Hydriotaphia: Urne-Buriall, or a Discourse of The Sepulchrall Urns Lately Found in Norfolk* (London, 1658), which has been often reprinted.

9 Alison Kelly, 'The Storied Urn', in *Decorative Wedgwood* (London, 1965); R. Reilly, *Wedgwood* (London, 1989), I.

10 A. Ray, *English Delftware Pottery* (London, 1968). The inscription is given here in a modernized version.

XVI · THE MONUMENTAL BODY

1 W. G. Sinclair Shaw, *The Story of Elmley Castle Church* (privately printed, 1948).

2 There is a substantial but largely disappointing literature on post-Reformation funeral monuments. John Physick has done valuable work in revising the bibliography of the standard monograph, M. D. Whinney's *Sculpture in Britain*. Great pioneers in this field include Rupert Gunnis, whose researches mostly found their way into his *Dictionary of British Sculptors, 1660–1851* (London, 1953, rev. 1968), and Katherine Ada Esdaile, whose vast bibliography is listed by John Physick and Nigel Ramsey in *Church Monuments*, i/2 (1986), pp. 117–33. Adam White is preparing a dictionary of sculptors working in the period before that covered by Gunnis. Many of the themes covered in this section of *The Art of Dying* are treated more substantially in my forthcoming *Signs of Life: Funeral Monuments in Post-Reformation England*.

3 See, for example, the imagery employed by George Abbot in *A Sermon Preached at the Funeral Solemnities of Thomas Earle of Dorset* (London, 1608), p. 3.

4 Vaughan, 'An Elegy on the Death of Mr R.W.', *Complete Poems*, p. 83.

5 Vaughan takes up this theme again in 'The Charnel House', *Complete Poems*, p. 72 (lines 7–8).

6 In Enright, ed., *The Oxford Book of Death*, p. 322.

7 Some churches housed astonishing numbers of corpses beneath their floors: J. Charles Cox cites the case of St Neots, Cornwall, where 548 persons were buried between 1606 and 1708, the area being stocked twice over during that time (*Churchwardens' Accounts*, p. 169).

8 A. Kreider, *English Chantries: The Road to Dissolution* (Cambridge, Mass., 1979).

9 Weever, *Ancient Funerall Monuments* (London, 1631), p. 11.

10 Richard Symonds, 'The Diary of the Marches kept by the Royal Army', ed. C. E. Long, *Camden Society*, lxxiv (1854), p. 134.

XVII · KINDS OF MONUMENT

1 John Page-Phillips, *Palimpsests: The Backs of Monumental Brasses*, 2 vols (London, *c. 1980*).

2 R. Hutchinson, 'Richard Haydocke, Brass Engraver and Sleeping Preacher', *Transactions of the Monumental Brass Society*, xi (1975), pp. 396–401; K. J. Höltgen, *Richard Haydocke: Translator, Engraver, Physician*, Bibliographical Society (London, 1978).

3 The Rich monument is attributed to Epiphanius Evesham by K. A. Esdaile in *Transactions of The Essex Archaeological Society*, new series xxii/1 (1936), pp. 59–67.

XVIII · IMAGE THEORY

1 N. B. Penny, *Church Monuments in Romantic England* (New Haven and London, 1977), and his valuable article 'English Church Monuments to Women who Died in Childbed between 1780 and 1835', *Journal of The Warburg and Courtauld Institutes*, xxxviii (1975), pp. 314–32.

2 Margaret Aston, *England's Iconoclasts, I: Laws against Images* (Oxford, 1989).

3 This historiographic theme goes back at least as far as the mid-eighteenth century; for its application to the history of sculpture see John Flaxman, *Lectures on Sculpture* (London, 1829).

4 On this see my contribution to the proceedings of the XXVII Conference of the Comité International d'Histoire de l'Art held at Strasbourg in 1989 on 'Art et les Révolutions': Nigel Llewellyn, 'Cromwell and the Tombs: Historiography and Style in post-Reformation English Funeral Monuments' (forthcoming).

5 B. Willsher and D. Hunter, *Stones: A Guide to Some Remarkable Eighteenth-century Gravestones* (Edinburgh and Vancouver, 1978), which has an excellent bibliography.

6 Tony and Mary Yoward (typical of the heroes among the membership of the Church Monuments Society) are undertaking pioneering work on this subject: meanwhile, see 'Cast-iron Gravestones', *Association for Industrial Archaeology*, xv/2 (1988).

7 See Lawrence Stone, *Sculpture in Britain: The Middle Ages* (2nd edn, Harmondsworth, 1972), pp. 98–9. The definitive account of Purbeck has yet to be written; for its material properties see Alec Clifton-Taylor's essay on 'Building Materials' in John Newman and Nikolaus Pevsner, *The Buildings of England: Dorset* (Harmondsworth, 1972), pp. 58–62.

8 Malcolm Baker, in a series of recent publications, has greatly improved our understanding of these practices: 'Roubiliac's Models and 18th-century English Sculptors' Working Practices', *Entwurf und Ausführung in der europäischen Barockplastik*, ed. P. Volk (Munich, 1986), pp. 59–84, and 'Rysbrack's Terracotta Model of Lady Foley and her Daughter

and The Foley Monument at Great Witley', *Staedel Jahrbuch*, new series xi (1987), pp. 261–8.

XIX · EPILOGUE

1 Richard Marks in a lecture (September 1988) given at Exeter College, Oxford, to the Church Monuments Society, and Philip Styles, 'Dugdale and The Civil War', *Transactions of the Birmingham and Warwickshire Archaeological Society*, lxxxvi (1974), pp. 132–47.
2 Richard Symonds, *passim*.
3 John Le Neve (1679–1741), *Monumenta Anglicana*, 5 vols (London, 1717–19), covering the period *c.* 1600–1718 and MS notes in British Library, Harleian MSS 3605–3624, 6127.
4 John Butt, *The Mid-Eighteenth Century*, Oxford History of English Literature, ed. G. Cornwall (Oxford, 1979), p. 78ff. For a recent study which argues that elegiac poetry is part of mourning and demands psychological treatment rather than a consideration as the 'poetry of praise', see G. W. Pigman III, *Grief and English Renaissance Elegy* (Cambridge, 1985), p. 5.
5 John Webster, *The Duchess of Malfi*, V, iii, quoted by Margaret Aston in 'English Ruins and English History: The Dissolution and the Sense of the Past', *Journal of the Courtauld and Warburg Institutes*, xxxvi (1973), p. 233.
6 Vaughan, 'Stay Passenger', *Complete Poems*, p. 436.
7 On McSwiny and his activities see F. J. B. Watson in the *Burlington Magazine*, xcv (1953), p. 363, and Francis Haskell, *Patrons and Painters: A Study in the Relations Between Italian Art and Society in the Age of the Baroque* (rev. edn, Oxford, 1980), pp. 287–92, 405–6.
8 Morley, *Death, Heaven and the Victorians*, *passim*.

SELECT BIBLIOGRAPHY

Ariès, Philippe, *Western Attitudes to Death*, London, 1974.
——, *The Hour of Our Death*, London, 1981.
Aubrey, John, *Brief Lives*, ed. D. L. Dick, Harmondsworth, 1972.
Backer, B. A., Hannon, N. & Russell, N. A., eds, *Death and Dying: Individuals and Institutions*, New York, 1982.
Badham, P., *Christian Beliefs about Life after Death*, London, 1978.
Baker, Malcolm, 'Roubiliac's Models and Eighteenth-Century English Sculptors' Working Practices', in P. Volk, ed., *Entwurf und Ausführung in der europäischen Barockplastik*, Munich, 1986, pp. 59–83.
Beaty, Nancy Lee, *The Craft of Dying: A Study of the Literary Tradition of The 'Ars Moriendi' in England*, New Haven, 1970.
Benkard, E., *Undying Faces*, London, 1929.
Bilder und Tänze des Todes: Gestalten des Todes in der europäischen Kunst seit dem Mittelalter (exhibition catalogue), Unna & Paderborn, 1982.
Białostocki, Jan, 'The Door of Death: Survival of a Classical Motif in Sepulchral Art', *Jahrbuch der Hamburger Kunstsammlungen*, xviii (1973), pp. 7–32.
——, 'The Image of Death and Funerary Art in European Tradition' in B. De La Fuente & L. Noelle, eds., *Arte Funerario*, pp. 11–32.
Bizley, A. C., *The Slate Figures of Cornwall*, Perranporth, 1965 (privately printed).
Bloch, Maurice & Parry, J., eds, *Death and the Regeneration of Life*, Cambridge, 1982.
Boase, T. S. R., *Death in the Middle Ages: Mortality, Judgement and Remembrance*, London, 1972.
Braet, H., & Verbecke, W., eds., *Death in the Middle Ages*, Leuvan, 1983.
Brandon, S. G. F., *The Personification of Death in Some Ancient Religions*, Manchester, 1961.
Burgess, F., *English Churchyard Memorials*, London, 1963.
Burke, Joseph, 'Archbishop Abbot's Tomb at Guildford: A Problem in Late Caroline Iconography', *Journal of The Warburg & Courtauld Institutes*, xii (1949), pp. 179–88.
Burnet, Gilbert, *Some Passages of The Life and Death of the Right Honourable John Earl of Rochester*, London, 1972 [facsimile of 1680 edition].
Bury, Shirley, *Sentimental Jewellery*, London, 1986.
Bynum, B. & Porter, R., eds., *William Hunter and the 18th-century Medical World*, Cambridge, 1985.
Carne, B., & Green, J. A., 'The Conservation of the St John Monument at Lydiard Tregoze', *Antiquaries Journal*, lxi (1981), pp. 115–22.
Christensen, Carl C., 'The Significance of the Epitaph Monument in Early Lutheran . . . Art . . .', in L. P. Buck & J. W. Zophy, eds, *The Social History of the Reformation*, Ohio, 1972.
Clark, J. M., *The Dance of Death in the Middle Ages and the Renaissance*, Glasgow, 1950.
Clifford, T., 'John Bacon and The Manufacturers', *Apollo*, cxxii (1985), p. 288–304.
Cohen, K., *Metamorphosis of a Death Symbol*, Berkeley, 1973.
Collinson, Hugh, *Country Monuments: Their Families and Houses*, Newton Abbot, 1975.
Colvin, Howard, & Stone, Lawrence, 'The Howard Tombs at Framlingham, Suffolk', *Archaeological Journal*, cxxii (1965), pp. 159–71.

Comper, F. M. M., *The Book of the Craft of Dying*, London, 1917.

Cunnington, P., & Lucas, C., *Costume for Births, Marriages and Deaths*, London, 1972.

Curl, James S., *A Celebration of Death*, London, 1980.

De La Fuente, Beatriz, & Noelle, Louise, eds, *Arte Funerario: Coloquio Internacional de Historia del Arte*, 2 vols, Mexico City, 1987.

Doebler, Bettie Anne, '"Dispaire and Dye": The Ultimate Temptation of Richard III', *Shakespeare Studies*, vii (1974), pp. 75–85.

——, 'Othello's Angels: The Ars Moriendi', *English Literary History*, xxxiv (1967), pp. 156–72.

Elias, Norbert, *The Loneliness of the Dying*, Oxford, 1985.

Enright, D. J., ed., *The Oxford Book of Death*, Oxford, 1983.

Esdaile, K. A., *English Church Monuments, 1510 to 1840*, London, 1946.

——, 'Notes on Three Monumental Drawings from Sir Edward Dering's Collections', *Archaeologia Cantiana*, xlvii (1935), pp. 219–34.

——, 'The Interaction of English and Low Country Sculpture in the Sixteenth Century', *Journal of The Warburg & Courtauld Institutes*, vi (1943), pp. 80–88.

Essick, R. N., & Paley, M. D., *Robert Blair's 'The Grave', Illustrated by William Blake: A Study with Facsimile*, London, 1982.

Eustace, K., ed., *Michael Rysbrack, Sculptor, 1694–1770*, City of Bristol Museums & Art Gallery exhibition catalogue, 1982.

Finucane, R. C., 'Sacred Corpses, Profane Carrion: Social Ideals and Death Rituals in the Later Middle Ages', in J. Whaley, ed., *Mirrors of Mortality*, pp. 40–60.

Fritz, Paul S., 'From "Public" to "Private": The Royal Funerals in England, 1500–1830', in J. Whaley, ed., *Mirrors of Mortality*, pp. 61–79.

Fulton, Robert, ed., *Death and Identity*, New York, 1965.

Gennep, A. Van, *The Rites of Passage*, Chicago, 1960 [first published 1908].

Gent, Lucy, and Llewellyn, Nigel, eds, *Renaissance Bodies: The Human Figure in English Culture, c. 1540–1660*, London, 1990.

Giesey, R. E., *The Royal Funeral Ceremony in Renaissance France*, Geneva, 1960.

Gittings, Clare, *Death, Burial and the Individual in Early Modern England*, London, 1984.

Gough, Richard, *Sepulchral Monuments in Great Britain*, 2 vols, London, 1786–96.

Greenhill, Frank A., *Incised Effigial Slabs . . . c. 1100–c. 1700*, 2 vols, London, 1976.

Greenhill, T., Νεχροχηδειο, or *The Art of Embalming*, London, 1705.

Gundersheimer, W. L., ed., *The 'Dance of Death' of Hans Holbein the Younger*, New York, 1971 [facsimile with introduction].

Gunnis, Rupert, *Dictionary of British Sculptors, 1660–1851*, rev. edn, London, 1968.

Haines, Herbert, *A Manual of Monumental Brasses*, London, 1861.

Hertz, Robert, *'Death' and 'The Right Hand'*, trans. R. & C. Needham, Glencoe, Illinois, 1960.

Hollis, George & Thomas, *The Monumental Effigies of Great Britain*, parts 1–6, London, 1840–42.

Hope, W. St John, 'On the Funeral Effigies of the Kings and Queens of England . . .', *Archaeologia*, lx/2 (1907), pp. 511–69.

Humphreys, Sally C., & King, H., eds, *Mortality and Immortality: The Anthropology and Archaeology of Death*, London, 1981.

Huntington, R., & Medcalf, P., *Celebrations of Death: The Anthropology of Mortuary Ritual*, Cambridge, 1979.

Hurtig, Judith, 'Seventeenth-century Shroud Tombs: Classical Revival and Anglican Context', *Art Bulletin*, lxiv (1982), pp. 217–28.

——, 'Death in Childbirth: Seventeenth-Century English Tombs and their Place in Contemporary Thought', *Art Bulletin*, lxv (1983), p. 603–15.

s'Jacob, Henriette, *Idealism and Realism: A Study of Sepulchral Symbolism*, Leiden, 1954.

Kantorowicz, E. H., *The King's Two Bodies: A Study in Medieval Political Theology*, Princeton, 1957.

Kemp, Brian, *English Church Monuments*, London, 1980.

Koller, E., *Totentanz: Versuch einer Textembeschreibung*, Innsbruck, 1980.

Kreider, Alan, *English Chantries: The Road to Dissolution*, Cambridge, Mass., 1979.

Lawson, S., 'Cadaver Effigies: The Portrait as Prediction', *Bulletin of the Board of Celtic Studies*, xxv (1974), pp. 519–23.

Le Neve, John, *Monumenta Anglicana*, 5 vols, London, 1717–19.

Levin, W. R., *et al.*, *Images of Love and Death in Late Medieval and Renaissance Art*, University of Michigan Museum exhibition catalogue, 1975–6.

Llewellyn, Nigel, *John Weever and English Funeral Monuments of the Sixteenth and Seventeenth Centuries*, unpublished Ph.D thesis, University of London, 1983.

——, 'English Renaissance Tombs: Commemoration in Society' in B. De La Fuente & L. Noelle, eds, *Arte Funerario*, pp. 143–54.

——, 'Accident or Design? John Gildon's Funeral Monuments and Italianate Taste in Elizabethan England', in E. Chaney & P. Mack, eds, *England and the Continental Renaissance: Essays in Honour of J. B. Trapp*, Woodbridge, 1990, pp. 143–52.

——, 'Claims to Status through Visual Codes: Heraldry on post-Reformation Funeral Monuments', in S. Anglo, ed., *Chivalry in the Renaissance*, Woodbridge, 1990, pp. 145–60.

——, 'The Royal Body: Monuments to The Dead, For The Living', in Gent & Llewellyn, eds, *Renaissance Bodies*, pp. 218–40.

Lord, John, 'Patronage and Church Monuments, 1660–1794: A Regional Study', *Church Monuments*, i/2 (1986), p. 95.

Ludwig, Allan I., *Graven Images; New England Stonecarving and Its Symbols 1650–1815*, Middletown, Conn., 1966.

Mandelbaum, D. G., 'Social Uses of Funeral Rites', in H. Feifel, ed., *The Meaning of Death*, New York, 1959, pp. 189–217.

Mann, J. G., 'Instances of Antiquarian Feeling in Medieval and Renaissance Art', *Archaeological Journal*, lxxxix (1932), pp. 254–74.

——, 'English Church Monuments, 1536–1625', *Walpole Society*, xxi (1932–33), pp. 1–22.

More, Thomas, 'The Realm of Death', *The English Works of Sir Thomas More*, London, 1931.

Morley, J., *Death, Heaven and the Victorians*, London, 1971.

Ormond, Rosalie, 'Body and Soul Dialogues in The Seventeenth Century', *English Literary Renaissance*, 1974 iv (1974), p. 363ff.

Page-Phillips, John, *Palimpsests: The Backs of Monumental Brasses*, 2 vols, London, *c.* 1980.

Panofsky, Erwin, *Tomb Sculpture: Its Changing Aspects From Ancient Egypt to Bernini*, London, 1964.

Peacock, John, 'Inigo Jones's Catafalque for James I', *Architectural History*, xxv (1982), pp. 1–5.

Pegg, P. F., & Metze, E., *Death and Dying: A Quality of Life*, London, 1981.

Penny, N. B., 'English Church Monuments to Women who Died in Childbed Between 1780 and 1835', *Journal of the Warburg & Courtauld Institutes*, xxxviii (1975), pp. 314–32.

——, *Church Monuments in Romantic England*, London, 1977.

——, *Mourning*, London, 1981.

Physick, J., *Designs for English Sculpture, 1680–1860*, London, 1969.

——, *Five Monuments from Eastwell*, London, 1973.

Pigler, A., 'Portraying the Dead', *Acta Historiae Artium*, Hungarian Academy of Science, IV, i–ii (1956), pp. 1–75.

Pigman III, G. W., *Grief and English Renaissance Elegy*, Cambridge, 1985.

Potterton, Homan, *Irish Church Monuments, 1570–1880*, Ulster Architectural Heritage Society, 1975.

Puckle, B. S., *Funeral Customs: Their Origin and Development*, London, 1926.

Richardson, Ruth, *Death, Dissection and the Destitute*, London, 1988.

Rotzler, W., *Die Begegnung der drei Lebenden und der drei Toten*, Winterthur, 1961.

Scarisbrick, Diana, 'A Becoming Mourning', *Country Life*, clxxxiv (18 Jan 1990), pp. 58–60.

Sheingarn, P. K. L., *Easter Sepulchres: A Study in the Relationship Between Art and Liturgy*, unpublished Ph.D. thesis, University of Wisconsin, 1974.

Skubiszewska, Maria, 'Death as Birth: The Symbol on the Tomb of the King of Poland', *Journal of the British Archaeological Association*, 3rd series, xxxvi (1973), p. 43.

Smith, J. T., *Nollekens and his Times*, Oxford, 1929.

Spiers, W. L., 'The Note-book and Account Book of Nicholas Stone', *Walpole Society*, vii (1919).

Stannard, David E., *The Puritan Way of Death: A Study of Religion, Culture and Social Change*, Oxford, 1977.

Stephenson, Mill, *A List of Monumental Brasses in the British Isles*, London, 1964 [first printed in 1926, with Appendix in 1938].

Stone, Lawrence, *Sculpture in Britain: The Middle Ages*, Harmondsworth, 1955.

——, 'The Verney Tomb at Middle Claydon', *Records of Bucks*, xvi (1955–6), pp. 66–82.

——, *The Family, Sex and Marriage in England, 1500–1800*, Harmondsworth, 1979.

——, 'Death' in his collection *The Past and the Present*, Boston, Mass., 1981.

Storck, W. F., 'Aspects of Death in English Art and Poetry', *Burlington Magazine*, xxi (1912), pp. 249–56 & 314–9.

Stothard, C. A. [with A. J. Kempe], *The Monumental Effigies of Great Britain*, London, 1876.

Strong, Roy, 'Sir Henry Unton and his Portrait: An Elizabethan Memorial Picture and Its History', *Archaeologia*, xcix (1965), pp. 53–76.

——, *National Portrait Gallery: Tudor and Jacobean Portraits*, 2 vols, London, 1969.

——, *The English Icon: Elizabethan and Jacobean Portraiture*, London, 1969.

Tanner, Joan D., 'Tombs of Royal Babies in Westminster Abbey', *Transactions of the British Archaeological Association*, xvi (1953), pp. 25–41.

Tanner, L. E. & Nevinson, J. L., 'On Some Later Funeral Effigies in Westminster Abbey', *Archaeologia*, lxxxv (1936), pp. 169–202.

Tate, F., 'Of the Antiquity, Variety and Ceremonies of Funerals in England', in T. Hearne, *A Collection of Curious Discourses . . .*, 2nd edn, 2 vols, London, 1771.

Taylor, J. H. M., ed., *Dies illa: Death in the Middle Ages*, Liverpool, 1984 [Proceedings of the 1983 Manchester Colloquium].

Taylor, Lou, *Mourning Dress: A Costume and Social History*, London, 1983.

Tenenti, A., *Il senso della morte e l'amore della vita nel rinascimento (Francia e Italia)*, Turin, 1957.

Thomas, K. V., *Religion and the Decline of Magic: Studies in Popular Beliefs in Sixteenth- and Seventeenth-century England*, London, 1971.

Totentänze aus sechs Jahrhunderten (exhibition catalogue), Ratingen, 1982.

Vovelle, M., *La Mort et l'occident de 1300 à nos jours*, Paris, 1983.

Wagner, A. R., *Heralds and Ancestors*, London, 1978.

Walker, D. P., *The Decline of Hell: Seventeenth-century Discussions of Eternal Torment*, London, 1964.

Wall, J., *The Tombs of the Kings of England*, London, 1891.

Weber, F. Parkes, *Aspects of Death in Art and Epigram*, 4th edn, London, 1914.

Weever, John, *Ancient Funerall Monuments*, London, 1631.

Whaley, Joachim, *Mirrors of Mortality: Studies in the Social History of Death*, London, 1981.

Whinney, Margaret D., *Sculpture in Britain, 1530–1830*, rev. edn by John Physick, Harmondsworth, 1988.

White, Adam, 'Classical Learning and the Early Stuart Renaissance', *Church Monuments*, i/1 (1985), pp. 20–33.

Willsher, B. & Hunter, D., *Stones: A Guide to Some Remarkable Eighteenth-century Gravestones*, Edinburgh, 1978.

Wirth, Jean, *La Jeune Fille et la mort: Recherches sur les thèmes macabres dans l'art germanique de la Renaissance*, Geneva, 1979.

Wright, H. B. & Spears, M. K., eds, *The Literary Works of Matthew Prior*, 2 vols, Oxford, 1959.

Yarrington, Alison, 'Nelson the Citizen Hero: State and Public Patronage of Monumental Sculpture, 1803–18', *Art History*, vi (1983), pp. 315–29.

Young, E., *Night Thoughts, or, The Complaint and The Consolation* [illustrations by William Blake], facsimile reprint of 1797 edn, London, 1976.

LIST OF ILLUSTRATIONS

nolds's *The Triumphs of God's Revenge Against . . . Murder* (7th edn, London, 1704). Victoria & Albert Museum.

26. 'Mr Legge', plaster, cast from a flayed corpse. Royal Academy of Arts, London.

27. Anon., *Thomas Braithwaite making his Will*, oil on canvas, 1607. Abbot Hall Art Gallery, Kendal, Cumbria.

28. Anon., *The Unton Memorial* picture, oil on panel, after 1596. National Portrait Gallery, London.

29. John Dwight (*c.* 1635–1703), 'Lydia Dwight on her Deathbed', stoneware made in Fulham, *c.* 1674. Victoria & Albert Museum.

30. John Dwight, 'Lydia Dwight Resurrected', stoneware made in Fulham, *c.* 1764. Victoria & Albert Museum.

31. William Hogarth, 'The Reward of Cruelty', engraving from the series *Four Stages of Cruelty*, 1751. Victoria & Albert Museum.

32. William Hogarth, 'The Idle Apprentice Executed at Tyburn', etching with engraving from the series *Industry and Idleness*, 1747. Victoria & Albert Museum.

33. John Souch, *Sir Thomas Aston at the Deathbed of his Wife*, oil on panel, 1635–6. Manchester City Art Galleries.

34. Southwood Smith (1788–1861) and Jacques Talisch (*d.* 1851), The Auto-Icon of Jeremy Bentham, natural materials, wax and textiles, 1832; restored 1981. University College, London.

35. (?)Thomas Simon (*c.* 1623–51), Death Mask of Oliver Cromwell, plaster, 1658. Ashmolean Museum, Oxford.

36. Richard Gaywood (*fl. c.* 1650–80), 'The Funeral Effigy and Hearse of Henry, Prince of Wales', etching and engraving, from Francis Sandford's *A Genealogical History of the Kings and Queens of England* (1707). National Art Library, Victoria & Albert Museum.

37. Coffin Furniture: A gilt-brass masonic grip-plate, *c.* 1790; stamped iron (formerly gilt) cartouche, 1760s. Victoria & Albert Museum.

38. Patent die-stamped coffin furniture, stamped iron gilt, 1839. Victoria & Albert Museum.

39. Page from a wholesale catalogue for Tuesby & Cooper's coffin furniture and iron-mongery warehouse, *c.* 1783. Victoria & Albert Museum.

40. Virgin's Crown (or Maiden's Garland), traditional design in wood and paper, late 18th century. St Mary, Abbotts Ann, Hampshire. (Photo: Author)

41. Paul Sandby (1725–1809), *Pall-Bearers accompanying the Coffin at a Spinster's Funeral*, pencil, before 1777. Victoria & Albert Museum.

42. Maximilian Colt (*c.* 1570–1645), Record Drawing of the Monument to Edward Talbot, Earl of Shrewsbury (*d.* 1618), erected in Westminster Abbey; pen and ink and bodycolour, from *The Book of Monuments* (1619). College of Arms, London.

43. Covered Bier, painted wood, 1611. South Wootton, Norfolk.

44. After Carel Allard, *The Funeral Procession of Mary II*, engraving by Lorenz Scherm (*fl.* 1690–after 1734), 1695. Victoria & Albert Museum.

45,46. Johann Theodor de Bry, Engraving from Thomas Lant's *Funeral of Philip Sidney* (1587). Victoria & Albert Museum.

47. Funerary Achievement and Monument of Sir William Penn, 1670; the achievement in steel comprises sword, breastplate, tassets, gauntlets, spurs and helmet, together with banners and the Penn crest. St Mary Redcliffe, Bristol. (Photograph: Victoria & Albert Museum)

48. Tabard of John Anstis the elder (1669–1744), Garter King of Arms, velvet embroidered in silks and metal threads, early 18th century. Victoria & Albert Museum.

49. Funeral Pall, late 15th-century Italian velvet and early 16th-century English embroidery. The Vintners' Company, London.
50. Funeral effigy of Edmund Sheffield, 2nd Duke of Buckingham, wood, leather, wax and textiles, 1735. Courtesy of the Dean and Chapter of Westminster Abbey, London.
51. Monument made in a Southwark workshop to Raphe and Elizabeth Wyseman, alabaster and imported 'marbles', originally polychromed, after 1954. St Mary and All Saints, Rivenhall, Essex. (Photo: Royal Commission on the Historical Monuments of England)
52. Randle Holme, Page from a mid-17th-century sketchbook, engraving (left) and pen and ink and bodycolour (right). British Library.
53. Attributed to Paul Sandby, *A Funeral Procession*, pencil and wash, late 18th century. Victoria & Albert Museum.
54. Biscuit Wrapper, early 19th century. Pitt Rivers Museum, University of Oxford.
55. Funeral Invitation addressed to Anthony Shepard, woodcut, 1705. Collection of the Hon. Christopher Lennox-Boyd.
56. Antoine Jongelinx after Noel Coypel (1628–1707), Invitation to the Funeral of Miss M. Foster, etching and engraving, 1737. Collection of the Hon. Christopher Lennox-Boyd.
57. Francesco Bartolozzi after Edward Francis Burney (1760–1848), Invitation to the Funeral of Sir Joshua Reynolds, etching, 1792. Collection of the Hon. Christopher Lennox-Boyd.
58. William Hogarth, *The Company of Undertakers*, etching and engraving, 1736. Victoria & Albert Museum.
59. Chasuble for Requiem Mass, velvet embroidered in silks and metal thread, with the Resurrection of the Dead and the monogram of Robert Thornton, Abbot of Jervaulx, *c*. 1510–30. Victoria & Albert Museum.
60. Sexton's Handbell, bell-metal, 1638. Victoria & Albert Museum.
61. Thomas Stothard (1755–1834), *Burying the Dead*, watercolour, *c*. 1792. Victoria & Albert Museum.
62. Thomas Rowlandson, *Mourning Figures around a Coffin*, pen and ink and wash, no date. Victoria & Albert Museum.
63. Thomas Stothard, *Studies of Figures for a Mourning Scene*, pen and ink, *c*. 1800. Victoria & Albert Museum.
64. Mourning Rings, gold, some enamelled and set with miniatures, human hair and precious and semi-precious stones; from left to right: 1788; 1790; *c*. 1795; late 16th century; 1764; mid-17th century. Victoria & Albert Museum.
65. The Tor Abbey Jewel, gold and enamel, *c*. 1546. Victoria & Albert Museum.
66. Epiphanius Evesham (1570–after 1633), Monument to the 2nd Lord Teynham, alabaster and imported 'marbles', after 1622. St Peter and St Paul, Lynsted, Kent. (Photo: Author)
67. Handwarmer with moralizing inscription, Lambeth delftware, 1672. Ashmolean Museum, Oxford.
68. Mourning Sword, hilt of blackened steel, early 18th century. Hammersmith Public Library, on loan to the Victoria & Albert Museum.
69. Page from the Album of Barbara Johnson (1746–1826), with sample of black lutestring labelled 'May 1771. Mourning for my Uncle Johnson'. Victoria & Albert Museum.
70. Woman's Riding Gauntlets, leather with embroidered satin cuffs, late 17th century. Museum of Costume, Bath. (Photo: Author)
71. Mourning Fan for Frederick, Prince of Wales, hand-coloured etching and engraving with ivory sticks, 1751. Collection of the Hon. Christopher Lennox-Boyd.

72,73. Memorial Slide for Elias Ashmole (1617–92), the reverse engraved 'E Ashmole 1692'; gold, set with crystal over knotted hair. Ashmolean Museum, Oxford.

74. John Greenhill (*c.* 1640/45–76), *Mrs Jane Cartwright*, oil on canvas, before 1676. Dulwich College Picture Gallery.

75. Ivory Picture attributed to G. Stephany and J. Dresch, 1800. City of Bristol Museum.

76. William Stanton (1639–1705), Monument to the 1st Earl of Coventry, marbles, after 1699. St. Mary, Elmley Castle, Hereford and Worcester. (Photo: Royal Commission on the Historical Monuments of England)

77. Gerard Johnson (1541–1611), Design for a Monument for John Gage (*d.* 1598) and his two wives, 1595. Courtesy of Viscount Gage. (Photograph: East Sussex Record Office)

78. L.-F. Roubiliac, Monument to George Frederick Handel, 1761. South transept of Westminster Abbey. (Photo: A. Kersting)

79. Monument to Thomas Plaifer (detail), polychromed freestone, after 1610. St Botolph, Cambridge. (Photo: Author)

80. Monument to an unknown knight, called Sir John de Hauteville, polychromed wood, (?)14th century, refurbished in the 16th century. St Andrew's, Chew Magna, Avon. (Photo: A Kersting)

81. Brasses from Dunstable, Bedfordshire, commemorating the Fayrey family, *c.* 1520, engraved brass. Victoria & Albert Museum.

82. Richard Haydocke (*d.* 1641), Memorial to Humphrey Willis, engraved brass, after 1613. Wells Cathedral, Somerset. (Photo: Royal Commission on the Historical Monuments of England)

83. Headstone to Susanna Symons, engraved slate, after 1729. St James, St Kew, Cornwall. (Photo: Royal Commission on the Historical Monuments of England)

84. Gerard Johnson and workshop, Monument to the 3rd Earl of Rutland, alabaster and imported 'marbles' with some original polychrome, 1591. St Mary, Bottesford, Leicestershire. (Photo: Royal Commission of the Historical Monuments of England)

85. (?)Richard Parker (*c.* 1520–71), Monument to Alexander and Anne Denton, alabaster, *c.* 1567. Hereford Cathedral. (Photo: Author)

86. Monument to Thomas Blount and family, alabaster and freestone, after 1561. St John the Baptist, Mamble, Hereford and Worcester. (Photo: Author)

87. Monument to two generations of the Maxey family, alabaster and imported 'marbles', late 1590s. Holy Trinity, Bradwell-juxta-Coggeshall, Essex. (Photo: Royal Commission on the Historical Monuments of England)

88. Attributed to Epiphanius Evesham, Monument to Lord Rich and his descendants, alabaster and imported 'marbles', *c.* 1620. Holy Cross, Felsted, Essex. (Photo: Royal Commission on the Historical Monuments of England)

89. Monument to John Southcotte (*d.* 1585) and his Wife, alabaster. St Nicholas, Witham, Essex. (Photo: Royal Commission on the Historical Monuments of England)

90. Cornelius Cure (?1540s–1607), Monument to Sir William Cordell (detail of personification of Prudence), alabaster and imported 'marbles', after 1580. Holy Trinity, Long Melford, Suffolk. (Photo: Author)

91. Memorial to Maria Forbes, local stone, after 1655. Churchyard of SS Peter and Paul and St Thomas of Canterbury. Bovey Tracey, Devon. (Photo: Author)

92. Memorial to Jane and Barbara Knight, cast-iron, after 1705. Churchyard of St George, Burrington, Hereford and Worcester. (Photo: Author)

93. Monuments to the Sylvester family, freestone, 1588–1654. Chapel of St John the Baptist, Burford, Oxfordshire. (Photo: A. Kersting)

94. William Stanton, Monument to Richard Sherburne (*d.* 1689) and his wife, Isabel (*d.*

ACKNOWLEDGEMENTS

My interest in commemorative art was first aroused by John Onians, my teacher at the University of East Anglia. Later, at the Warburg Institute, under the supervision of J. B. Trapp, I took up the subject once again. Among my colleagues at Sussex, Maurice Howard has been a constant source of encouragement and a positive mine of information. Others, Marcia Pointon especially, have passed on positive criticism of my methods and offered plenty of ideas. I owe a special debt to Lucy Gent, who read a late draft of the book and made innumerable intelligent and elegant suggestions about how the text might be improved.

This book takes its form from the exhibition 'The Art of Death' held at the Victoria & Albert Museum, which it is intended to accompany and supplement. My involvement in the V&A project would not have been possible without the interest and support of the Director, Mrs Elizabeth Esteve-Coll, of John Murdoch, the Assistant Director, and, at a crucial early stage, of Charles Saumarez Smith, now Head of Research. Malcolm Baker has been a stalwart comrade. Week-by-week encouragement, a rare professionalism and great good humour – often in the face of morbid material and difficult circumstances – has come from the Head of the Exhibitions Department, Linda Lloyd-Jones, and from her colleagues. The work of Hilary Young has been central to the success of the project. He has been enormously helpful at every stage and has masterminded all the practical aspects of the show, including familiarizing me with such useful vocabulary as the verb 'to sky'.

I have made constant use of the expertise and written records of the curatorial departments at the V&A, which remain a massive storehouse of learning. I have also learned a great deal from many conversations with curators; however, the arguments made both by the exhibition and by this book are mine alone. For part of the project an exchange was set up between the V&A and the University of Sussex, which allowed me a little more time for researching *The Art of Death*. Both institutions have shown admirable flexibility in organizing and managing this facility. Although their kindness will be indicated in the exhibition itself, I would like to thank the numerous institutions and individuals who have agreed to the loan of exhibits: the full potential of the project could not have been realized had we been obliged to rely solely on the holdings of the V&A, substantial though they are. My collaborator at the V&A has been Julian Litten, whose expertise in this field is such that he has often left me wondering how it might have been gained this side of the grave.

INDEX

(Numbers in *italics* refer to illustrations)